MUGHAL
MINIATURES

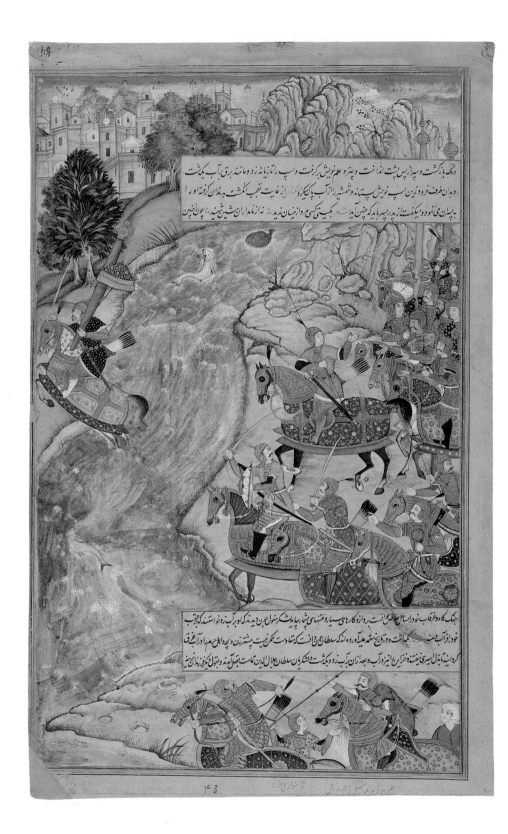

MUGHAL MINIATURES

J. M. Rogers

THAMES AND HUDSON

To A.L.

Front cover: Prince Khurram weighed in gold and silver. (See fig. 58)

Frontispiece: Jalāl al-Dīn Khwārazmshāh escaping from Jenghis Khan, across
the Indus. Composition and faces by Dharmdās; painted by Banwarī the
Younger. 38 × 24.1 cm (page); 32.6 × 22 cm (inside margins). Gouache on paper.
From the *Chingiskhān-nāme*, a version of Rashīd al-Dīn's *Jāmiʿ al-Tawārīkh*
[World History], made for Akbar, 1596–1600. Jalāl al-Dīn, Jenghis Khan's
principal Muslim adversary, earned the respect of all his Muslim
contemporaries. The incident is dated early 618/spring 1221. The section of the
Jāmiʿ al-Tawārīkh on which the *Chingiskhān-nāme* was based does not survive
in any early illustrated copy.

CONTENTS

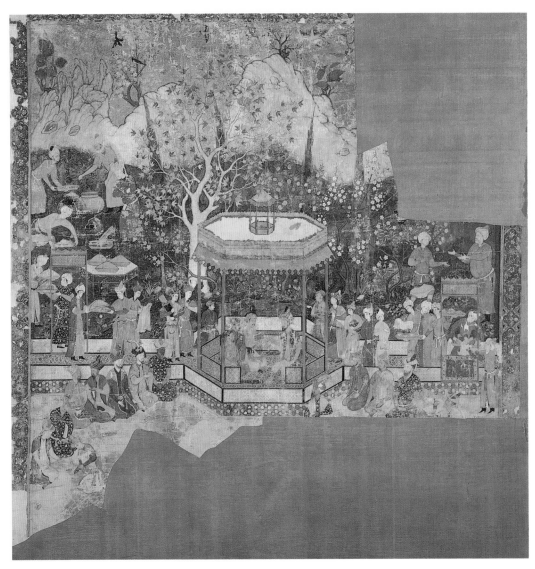

1 'The Princes of the House of Timur' (whole painting), attributable to ʿAbd al-Ṣamad, c.1550–5. 108.5 × 108 cm. Gouache on cotton gauze.

The original composition, into which Akbar, Jahāngīr and the future Shāh Jahān were all painted, probably showed Bābur receiving one of his sons. Executed most probably at Kabul, for one of Humāyūn's residences, before he had recaptured the Indian throne.

PREFACE

Mughal painting could be described as a variety of Islamic painting practised in India principally in the sixteenth and seventeenth centuries. But it is neither typically Muslim nor exactly Indian. A preliminary word is therefore needed on the scope of the present survey. Though Bābur in his memoirs concedes that able craftsmen of all sorts abounded in India, he also, if somewhat extravagantly, bewails the absence of fine art. This could be taken to imply that he had also judged Indian painting and found it wanting. For his taste in art was, understandably, for the superb refinement of Herat painting under the later Timurids towards the end of the fifteenth century, while Indian painting was in contrast too popular or alien to his religious sympathies. However, it is very clear that he found himself unable to ignore it. Despite the influence of the Muslim dynasties established in Northern India from the late twelfth century onwards, public figural religious art was astoundingly conspicuous – not only the sculpture of Hindu and Jain temples, but all sorts of popular pictorial arts associated with them, notably woven, painted or printed textiles which were used as awnings, curtains or draperies. Hindus and Jains also had their sacred books, all with elaborate iconographies.

There was even a lively tradition of book-painting at the Muslim courts of India in the fifteenth century which had arisen on the collapse of central Muslim power under the impact of Tamerlane's invasion of 1399. Here there grew up schools of somewhat Indianised wall-painting and book-illustration which are generally loosely described as 'Sultanate'. Their pretensions were sometimes

modest. They were all more or less indebted to metropolitan Persian sources and were influenced more or less by the painting of Shiraz, which was by 1450 becoming known as the principal centre of commercial manuscript production in Persia. There was probably little interaction between these various 'Sultanate' schools – in Mandu, Gujarat, Golconda and Bengal – but, particularly in Bengal, they were persistent and, in the seventeenth century, as production in the Imperial studio gradually declined, the appearance of 'sub-Imperial' or 'popular Mughal' styles owes much to them.

Comprehensive accounts of painting in sixteenth- and seventeenth-century Mughal India thus give these 'Sultanate' schools, no less than Hindu and Jain painting, their due importance. The present account, however, makes no pretence at comprehensiveness. Its purpose is to consider the development of painting from the Mughals' own point of view and their achievement, the creation of a school of painting by welding a very diverse mixture of cultural, religious and artistic traditions into one of the richest and most productive schools in the whole history of Islamic painting. This was executed in the Imperial Mughal studio and we therefore follow it from its origins under Humāyūn up to the death of Awrangzīb in 1707. Under Akbar, at least, many of the painters employed there were certainly Hindu, and may even have had Jain colleagues too, but their workmanship, even when illustrating works on Hindu epic, myth and religion for Akbar, was governed far less by the traditions of religious painting in which they had been reared than by the commanding tastes of an emperor and his heirs.

The patronage of this studio-scriptorium by the Mughal emperors also governs the temporal scope of this survey. Although paintings in the styles favoured by Shāh Jahān and Awrangzīb (and sometimes even by Jahāngīr) continued to be produced sporadically practically up to the extinction of the Mughal dynasty in 1858, they are little more than the ghost of a great past: there was no longer a permanent studio; and although in this late period Indian painting gave rise to one spectacular offshoot, the Company School of bird-, flower- and animal-painting, these were executed primarily for British clients in India. They must, therefore, be considered elsewhere.

There is one further limitation. Abundant historical evidence exists for wall-paintings in Mughal tombs and palaces, and in their heyday the latter would have had masses of decorated hangings, awnings and tents to make them habitable in the full heat of the summer months. From manuscript illustrations we get a very good

idea of what they were like, but the actual remains of the wall-paintings are negligible. Hence the concentration here upon illustrated manuscripts and albums, where the embarrassment, if there is one, is not of poverty but riches.

REGNAL DATES

The Muslim calendar is lunar, and starts from 622 AD. The AD equivalents rarely coincide exactly so are often given in pairs of years (except when an accession or death date is referred to; these, obviously, may be given precisely). The Mughals in India some-times made dates more exact by giving the month and day of the lunar calendar, the year of their own reign ('first regnal year' etc) and sometimes the month of the Persian solar calendar too.

932–37/1526–30 Bābur
937–47/1530–40; 962–63/1555–56 Humāyūn
963–1014/1556–1605 Akbar
1014–37/1605–27 Shāh Salīm [Jahāngīr]
1037–68/1628–57 Khurram [Shāh Jahān]
1068–1118/1658–1707 Awrangzīb [ʿĀlamgīr I]

Note on
Transliteration

Hindu and Sanskrit names are given in their anglicised forms (for example, Krishna, Shiva) or, where these do not exist, in simplified transcription. For Arabic names and titles the standard transliteration has been used, with slight modifications for Persian: where the letter *wāw*, pronounced **w** or **ū** in Arabic, is pronounced **v** in Persian, **v** accordingly is used here; and the letter *ḍāḍ*, pronounced in Arabic as a velarised **d**, is pronounced **z** in Persian and is given here as **ż**. The inconsistency, if regrettable, is difficult to avoid; and since many names, like that of Abu' l-Fażl, the author of the principal biographical work of Akbar's reign, the *Āyin-i Akbarī*, have become familiar in this form, consistency would merely confuse the reader.

As for the spelling of artists' names, that was no more standardised in Mughal India than in Shakespeare's England. Many recurring names, moreover, have different epithets, making it unclear whether they refer to one and the same individual or not. This complicates the matter of attribution quite considerably. Further study of signed or reliably attributed works will do something to remedy this confusion, but caution in attribution is particularly necessary with Mughal painters. Many of them made unsigned copies of their more important works, but there are a large number of skilful later copies with often fanciful or wishful attributions which are difficult to identify as such. And the corporate nature of manuscript illustration in the Mughal studio makes it correspondingly difficult to evaluate the contribution of the individuals whose names are so often recorded in the margins by librarians or overseers.

ACKNOWLEDGEMENTS

For photographic material I am grateful to the Trustees of the British Museum, the British Library Board, the Trustees of the Victoria and Albert Museum, the Governors of the School of Oriental and African Studies of the University of London, Dr Andrew Topsfield and the Visitors of the Ashmolean Museum, Professor Milo Cleveland Beach and the Sackler Museum, Washington DC, and Mr Nabil Saidi of Sotheby's. Mr Jeremiah Losty of the British Library, Professor Stuart Cary Welch, Mr John Rowlands, Mr David Scrace, Mr Robert Skelton, Sir Howard Hodgkin and Professor Beach have also been generous on many occasions with their time and information in showing me material or discussing problems of style and transmission. I also owe much to the kindness of Mr Peter Stocks of the British Library, particularly in the agreeable days when the Department of Oriental Manuscripts was located in Store Street, WC1. My editor Miss Carolyn Jones has made order out of a more than usually scrambled draft. My former colleagues in the Department of Oriental Antiquities in the British Museum have shown encouragement and forbearance in practically equal measure. And special thanks are due to Mrs Lay Goh of that department for her cheerful patience, and for the care and speed of her typing.

J. M. Rogers
SCHOOL OF ORIENTAL AND AFRICAN STUDIES
UNIVERSITY OF LONDON

— 1 —

THE MUGHALS AND
THEIR EMPIRE

Bābur, known as 'the Tiger', the founder of the Mughal empire in Northern India, who died in 1530, was not only the great-, great-, great-grandson of the Turkish conqueror, Tamerlane, but through his mother, the daughter of Yūnas Khān (d.1487), also a descendant of the notorious Mongol conqueror, Jenghis Khān. This lineage, of which Bābur was himself immensely proud, was exalted by his descendants in India who took the name Mughals ('Mongols') in memory of it. Even though, under Akbar, Chaghatay (also known as Turkī), the eastern Turkish dialect in which Bābur had written, came increasingly to be displaced by Persian as a court language, consciousness of the Mongol-Timurid lineage was to be crucial for the development of Mughal culture. The passage of time had obscured the blood-thirstiness of the tyrants of the past; and their imperial achievement in uniting the fluctuating peoples of the steppes and subjecting them to their law served as an example to the Mughals in their own struggle to weld into an empire the kaleidoscope of races and religions of the Indian kingdoms they had gradually conquered.

Bābur was born only shortly before the break-up of the Timurid domains under the onslaughts of Turkish dynasties in Central Asia and Iran, the Uzbeks and the Safavids. He had come to an understanding with his immediate relatives that he should inherit Samarkand and Transoxania, but despite long and bitter warfare

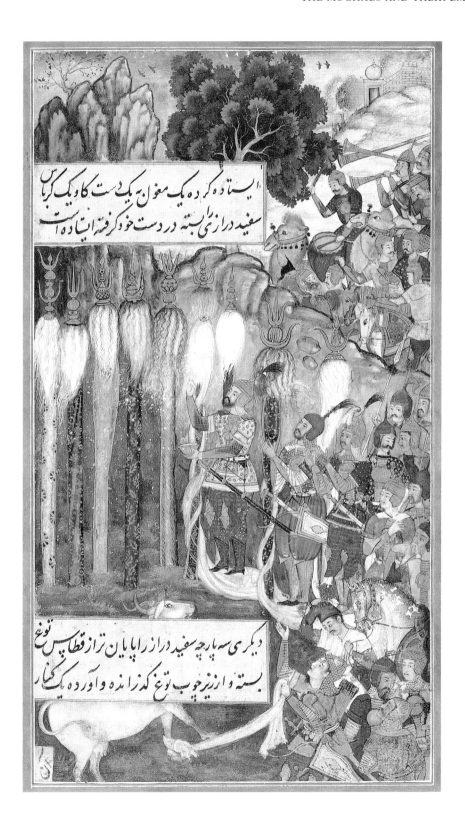

3 OPPOSITE Jesuit with the Virgin and Child and an attendant. 20.3 × 13 cm. Gouache on paper. He is probably pointing to an image, not conversing with them. *c.*1610.

he never succeeded in holding Samarkand for more than a few months at a time. He was gradually forced southwards, to Kabul, which he first captured in 1504, and then to Lahore. Encouraged by a discontented faction at the Lōdī court in Delhi, he defeated successively the Lōdī Sultan Ibrāhīm II at Panipat in 1526, a signal triumph over vastly superior manpower and elephants; the Rajput chieftains at Kanwa near Agra in the following year; and Maḥmūd Lōdī in 1529. On Bābur's death in 1530 Humāyūn was proclaimed ruler of India – that is, of Northern India and Pakistan in modern terms. But Bābur's troops, though loyal to Humāyūn, were few: India was vast and there had been no time to establish more than the most basic financial and legal administration of the territories he had occupied. Squabbles between his younger brothers and the powerful opposition of Afghan chieftains under Shīr Shāh Sūrī quite soon made his position untenable: he fled to Kandahar and Kabul in 1540, but three years later was forced to seek refuge with the Safavid Shāh Ṭahmāsp at Tabriz. After many humiliations and difficulties Humāyūn persuaded the Shāh to lend him troops to oust his brother, Kamrān Mīrzā, from Kabul in 1545. Kabul then became his bridgehead for a renewed assault on India against the now weak and divided successors of Shīr Shāh. In 1555, only a year before his death, he re-established himself at Delhi.

The real creator of the Mughal empire in India was Akbar (1556–1605), who at his accession was hardly fourteen years old. Through alliance, military conquest and marriage ties he reinforced his hold on Northern and Central India; Malwa, the independent Rajput states, Gujarat and Khandesh were subjugated; and by 1576 even Bengal was under his control. The north-west frontier was secured by the strengthening of Kandahar and Kabul. And in the Deccan the successors of the Bahmānid Sultanates were either annexed or made to recognise Mughal political and fiscal suzerainty. This union was achieved by peaceful means as well as by conquest. In 1562 Akbar married the daughter of the Rajah of Amber who later became known as Maryam Zamānī, thus bringing much of Rajasthan within his influence. Initially his capitals were at Agra and the nearby Fatehpur Sikri, where he resided till 1585. In the latter part of his reign, as Safavid and Uzbek expansionism in the north led him to concentrate upon the north-west frontier territories, Lahore became his principal base.

Artistically speaking, the conquest of Gujarat and the siege of the port of Surat (January 1573) was particularly important, for it brought Akbar into direct contact with the Portuguese. Good relations with them were vital for the security of the annual pilgrimage fleet to Mecca and Medina, though, ironically, Akbar's

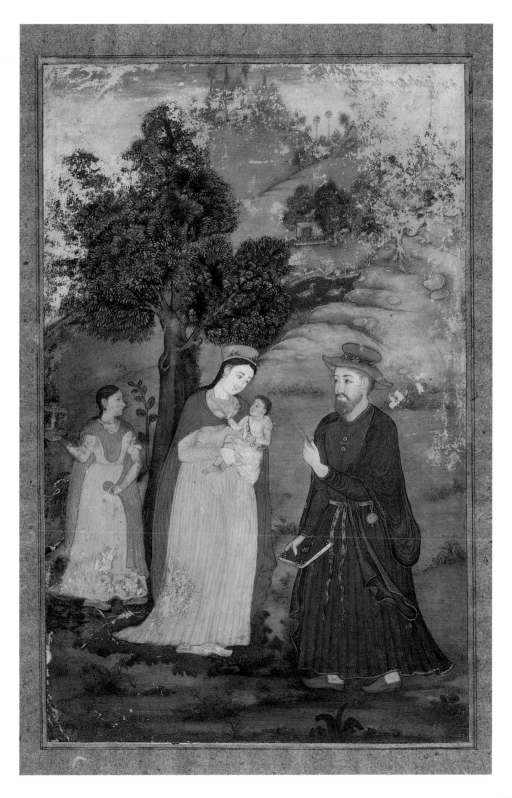

increasingly syncretistic religious theories almost immediately afterwards led him to discourage the *ḥajj* (the pilgrimage to Mecca and Medina which the Muslim believer is obliged to make at least once during his lifetime). In 1575 he boldly proclaimed, quite aberrantly for a Muslim ruler, the foundation of a central institution, the Dār al-ʿIbāda, in which not only the religions officially tolerated by the Muslim world (Christians, Jews and Zoroastrians) but Hindus too would be reconciled. This was followed in 1579 by the much more radical proclamation of a universal faith, the Dīn-i Ilāhī, and it is striking evidence of his absolute power that, though head of a *Muslim* empire, this did not cause his ministers to rebel and depose him.

Akbar also needed the Portuguese, however, for their ordnance, without which his goal of conquest in the sub-continent would have been in vain; and their culture and Christianity profoundly attracted him. The result was that a two-year Mughal mission to the Portuguese centre of Goa in 1575–78 to acquire European rarities for Akbar's court was followed by a Jesuit mission which was warmly received at Agra and Fatehpur Sikri, though Akbar found their preaching on chastity as uncongenial as their theology of the Trinity. The books they brought with them, including the great polyglot Bible printed by Plantin at Antwerp (1569–72), may have had little immediate influence upon the painting of the Imperial studio, though other illustrated biblical texts – for example, an illustrated *Acts of the Apostles* and the *Apocrypha* presented to Jahāngīr by the Jesuit Fr Fernam Guerreiro – soon came to be used as source books for the decoration of Mughal palaces. The wall-paintings in so many of the illustrations to the *Khamsa* of Niẓāmī made for Akbar in 1595 show this tradition to have been well established at the Mughal court even before 1600. But the arrival of the Jesuit mission opened the way to a flood of Flemish and North German prints which the Jesuits had acquired at Antwerp on their way to India and, Jeremiah Losty has suggested, may have been esteemed by Akbar from their very first appearance not merely as subject matter for Mughal painting but also as sources for modelling and perspective for the works currently being produced in his studio.

Towards the end of his reign Akbar became increasingly anti-Portuguese. His relations with his eldest son Jahāngīr also worsened considerably, though since Jahāngīr pursued friendship with the Jesuits and their Portuguese connections as an instrument of opposition to his father, their influence remained strong. In 1599 Jahāngīr seceded and established himself briefly at Allahabad with his court. On Akbar's death in 1605, however, he returned to Agra

to pursue his father's goal of enforcing obedience on the outlying parts of the Mughal empire. But for the years 1613–16, when, supporting the campaign of his son Prince Khurram (Shāh Jahān) against the Rana of Mewar, the chief of the Rajput rulers, he established his court at Ajmir in Rajasthan, Agra remained his principal capital. In the later years of his reign Jahāngīr became increasingly remote from government and, one Portuguese observer remarked, took to eating opium with a spoon, 'like cheese'. In the resultant power vacuum, although Shāh Jahān was Jahāngīr's elder son and therefore heir apparent, his succession was impeded by the politicking and intrigues of Jahāngīr's able wife, Nūr Jahān, who only on Jahāngīr's death was worsted and forced into retirement near Lahore. In 1657, towards the end of Shāh Jahān's long reign, he himself was deposed and imprisoned by his son Awrangzīb, who in a brief but savage civil war defeated his brother Dārā Shikōh.

In total contrast with Akbar, who, by allying himself with non-Muslims and even with elements regarded as heterodox by the Muslim population, had established himself as absolute, more on the model of a European despot than an Islamic ruler and virtually outside the Islamic conception of kingship, Awrangzīb, who was to rule for fifty years as ʿĀlamgīr I, attempted to enforce orthodox Sunnism. Among his successes was the complete subjugation of the Deccan and its largely Shiʿi rulers, who, by their encouragement of Maratha guerrillas, had been a thorn in the Mughals' flesh ever since the reign of Jahāngīr. Awrangzīb's seal in many great Mughal manuscripts from the Imperial library attests that he was no less proud of them than were Jahāngīr and Shāh Jahān, and a number of state portraits and fine court scenes were executed for him, but his reign shows a marked decline in expenditure on painting. Although the sumptuously illuminated margins of pages from the Polier album in the British Museum show that, even in the eighteenth century, there was fine workmanship available to those who could afford it, the Imperial studio was largely disbanded and the production of Imperial albums, no less than the arts of the illustrated book, went largely into abeyance. Awrangzīb's death marks the end of Mughal absolutism; his successors were weak and their reigns short. But the great period of patronage and achievement in Mughal painting was already long over.

— 2 —

MATERIALS, TECHNIQUES AND WORKSHOP PRACTICE

Probably the most important task facing the Mughal court painters was the production of luxuriously illustrated or illuminated manuscripts and albums, the latter the contemporary equivalent of the coffee-table book. The materials were expensive and the projects highly labour-intensive. The late appearance of printing in Islam has often been taken as a sign of the technological backwardness of later Muslim cultures, but, certainly up to the late sixteenth century, the superiority of Europe was by no means absolute. Calligraphic hands were an accomplishment of the well-educated man and texts could be cheaply copied and rapidly diffused, whereas defective distribution in the European book trade and often tiny printed editions were for many decades serious obstacles to the diffusion of knowledge. Nor, even in Europe, did printing drive manuscripts off the market. On the contrary, at least up to 1600, luxury manuscripts illustrated and illuminated for the great bibliophiles of Europe continued in great demand. There was, however, a significant difference: in Mughal India the manuscripts illustrated or illuminated for the commercial market were probably very much the exception and essentially a by-product of court scriptoria, rather than, as in contemporary Europe, a basis for the luxury side of the craft. The Imperial Mughal albums followed the traditions of the Timurids and Turcomans before them and of their contemporaries, the Safavids and the Ottomans, in combining

paintings, drawings and specimens of the work of famous calligraphers, often by earlier masters and the heirlooms of their libraries. These pages would be refurbished and mounted in the studio in richly illuminated margins and then bound with the finest stamped leather or lacquer covers.

With the exception of the *Hamza-nāme* made for Akbar early in his reign and of some later album leaves, mostly of larger format, which were executed on primed cotton or gauze, Mughal painting was on paper. Though 'Hindī' paper was prized abroad and modern India paper, originally made in Kashmir, is still the most admired for its fineness and thinness, early Indian papers are not generally of high quality and, till 1600 at least, the paper for manuscripts for the palace would have been imported from Persia, and possibly from Italy too. Before being issued to the calligrapher or scribe it was sized and polished to make it impermeable to the ink or other colouring. Lines were lightly impressed as a guide to the writer, and margins were drawn if not at that stage illuminated: in a sense these were the most important operations since they determined the format of the result, and scriptoria therefore had specialised marginators. Only exceptionally are subsequent changes of mind evident, as with the manuscript of the *Anvār-i Suhaylī* made for Akbar in Rabīʿ II 978/September 1570, now in the School of Oriental and African Studies of the University of London: when it came to be illustrated it was decided to ignore the original margins (cf. fig. 86); this case suggests that the organisation of Akbar's studio was still at a formative stage.

In Mughal India the most prized calligraphic hand was *nastaʿlīq*, which had been refined at the Timurid courts of the fifteenth century in Persia and Central Asia, though Korans, for fear that illegibility might lead to corruption of the text, continued to be written in the traditional rounded scripts. *Nastaʿlīq* was not a quick script to write; great care, moreover, had to be taken to get the text right, for correction was difficult and unsightly. Ink was normally black, thickened with gum Arabic and sometimes sprinkled with gold.

Recent work on major Persian and Mughal manuscripts shows that they were often written over a period of years, sometimes in quite haphazard order. The pace of production was of great importance: autocratic monarchs, having commanded a manuscript, were not disposed to wait patiently till it pleased their studios to present the finished work, so that every moment counted. The sheets of text had generally then to be inlaid in margins of stouter paper, which themselves were often to be illuminated or sprinkled with gold, but from this stage painters and illuminators

could work together. The pages mostly had catchwords to keep them in sequence as a guide to the painters and for the binder; none the less, the speed of production was such that wrongly bound manuscripts are not infrequent.

Illustration, on the other hand, had to wait upon the completion of a whole sequence of prior operations; and only in a work with discrete sections, like the *Khamsa* of Niẓāmī, could work on the illustration have properly begun as soon as each section was complete. At the stage of illustration, specialisation in the Mughal studio becomes much more marked. The underlying drawing was in black, sometimes done in ink with a pen or brush but more often in charcoal. Corrections were in white. The colours, in a variety of media loosely but generally termed 'gouache', were partly opaque pigments – including orpiment for yellow, cinnabar for red, copper salts for viridian and lapis lazuli for deep blue – and partly organic, including saffron, lake for crimson (from the lac insect, which owes its name to the Sanskrit *lakh*, meaning 100,000: vast numbers were needed to produce the dye), indigo for blue and (an Indian peculiarity) peori, a vivid yellow produced from the urine of cows which had been fed on mango leaves.

Inadequate as the sum of our knowledge of Mughal painting may be, we know far more about manuscript production in the Imperial Mughal studio than in any other Islamic culture. Innumerable librarians' notes on paintings show that the work was divided into at least three separate categories: the initial sketch for the composition (*ṭarḥ*); the portraits or faces (*chihranāmī*); and, finally, the colouring-in (*rangāmizī*). In many cases, different artists worked on each stage and through successive notes, it is possible to trace the progress of a painting from sketching right up to colouring in. Largely as a result of this division of work, however, it is often difficult to tie in the names of the painters which are given with a particular stylistic contribution or to follow how their style developed. Although many attempts have been made to isolate corpuses of their work, therefore, these lack the conviction of a European art historian's discussion of, say, Rubens or Titian. In fact, the various illustrations in a single manuscript, even in one as lavish as the *Khamsa* of Niẓāmī made for Akbar at Agra in 1595, to which practically all his finest painters contributed, tend to show a more marked resemblance to one another than the individual paintings of these same painters over a range of manuscripts. The specialisation in the studio must thus have gone with a considerable measure of centralised control.

This makes it often difficult to evaluate the attributions on Mughal paintings. Are they the craftsman's own record (crafts-

4 OPPOSITE Virgin and Child. Album leaf, after an engraving of the school of Bernart van Orley (1492–1542). 10.5 × 7 cm. Ink and wash on paper. Inscribed *raqm-i ghulām-i Shāh Salīm*, 'the work of the slave of Shāh Salim', the title which Jahāngīr took in 1600 on his secession to Allahabad. The inscription is a pun, in fact, for it refers to one of his painters called Ghulām, others of whose signed works survive. *c*.1600.

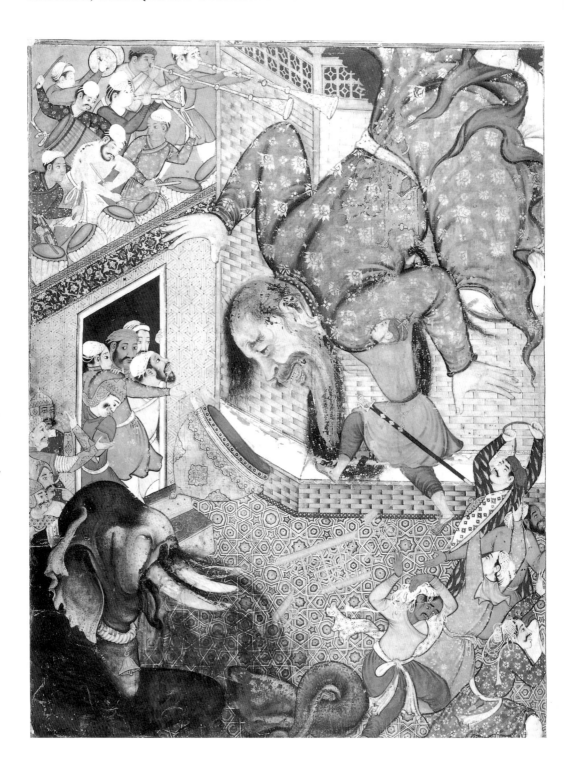

men's *signatures* are in fact rare)? Do they, like a trade mark, record the original composition being used here as a model? Are they the clerk's, or the patron's, record of who is owed payment for the work? Or do they merely express a wish by a later connoisseur that those particular artists had painted them? It is unfortunately often unclear.

What librarians' notes in manuscripts do clearly indicate, however, is the painters' training. In many cases through dated or datable work we can trace their advance from colouring (*rangāmizī*) to composition (*ṭarḥ*) to the painting of faces or portraits (*chihranāmī*). (The painting of faces was particularly highly regarded in the Mughal studio, and in some manuscripts produced outside the Mughal empire, particularly those which reached India from Bukhara, many of the faces have been repainted to Mughal taste.) There is also some evidence that a painter might at the outset of his career be set to illumination, the execution of medallions, book-plates, frontispieces and head-pieces. Such was the case with the renowned bird-, animal- and flower-painter, Manṣūr, who signed an illuminated head-piece in the British Library copy of the *Akbar-nāme* of *c*.1589. This might seem a surprising debut, since fine illumination was such a specialised craft that other practitioners, like Khwāja Jān, who signed several of the illuminations of the *Khamsa* of Niẓāmī made for Akbar in 1595, evidently devoted their careers to it. It might, therefore, suggest that Manṣūr and other painters were able to change their specialities in midcareer. A more obvious reason might be, however, that although illumination permitted a great deal of originality in composition and colouring, even the most complex medallions and frontispieces used a basic repertory of stencils which could relatively easily be assembled, even by an inexperienced craftsman, so that it was largely mechanical and suitable for a beginner. A painting in the 'Leningrad' album, now in the library of the Oriental Institute of the Academy of Sciences in St Petersburg, provides independent evidence that Manṣūr started in this way. It contains a portrait of Jahāngīr on which Manṣūr collaborated with Manōhar, showing him enthroned and probably datable to the year of his accession, 1605. Whereas Jahāngīr's head is boldly modelled and the folds of his gown fall softly in a style comparable to that of other paintings by Manōhar, his throne is made up of illuminated panels including a border and a head-piece almost identical to the illuminations of the 1595 *Khamsa*. There can be no doubt that this was Manṣūr's contribution to the portrait.

The highly original effects achieved in the Mughal studio may make it seem surprising that originality as such was actually given

5 OPPOSITE Fall of the giant, Zumurrud Shāh, the chief of the fireworshippers. *c*.1562–77. From the *Ḥamzanāme*. 68.3 × 52.5 cm. Gouache on gauze.

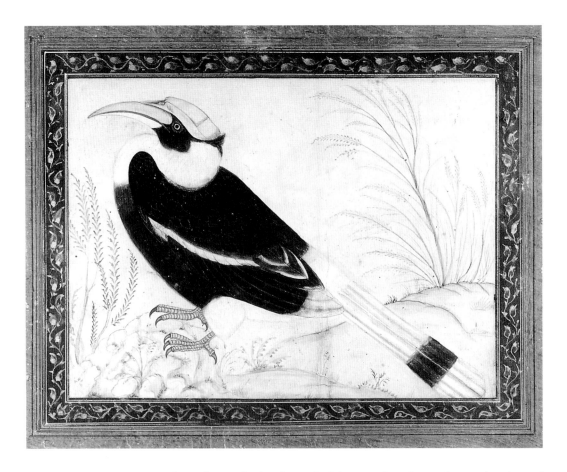

6 Hornbill. By Manṣūr, or copied from an original by him. Period of Jahāngīr (1605–27). 14.5 × 19.8 cm. Gouache on paper. There is another version of this study in the Shāh Jahān album in the Metropolitan Museum, New York.

7 OPPOSITE Man of Sorrows. Album leaf, Stowe Album 16. Copy c.1700–50 of a Mughal painting of the period of Jahāngīr (1605–27), after an engraving of the German school. 25.3 × 18 cm. Gouache on paper.

rather a low priority there. In Islam, as in other cultures dominated by the illustrated book, like that of mediaeval Europe, painting tended to be very conservative. Patrons usually demanded that the same subjects be illustrated, or, very often, even required a copy of a particular painting or manuscript, so that the possibility of stylistic innovation seemed to depend less upon the patron's taste than upon his discovery of new texts to illustrate, as happened to great and profitable consequence under Akbar. For sixteenth- and seventeenth-century Persian writers on painting one principal criterion of the excellence of an artist was that he should make the best copies and, as Jahāngīr boasted and as the British in eighteenth- and nineteenth-century India were to discover for themselves, Indian artists copied beautifully. Much of this was freehand, but the urgency of production in the Mughal scriptorium was such that mechanical aids, notably stencils, were used as much as possible, particularly in scenes in which the emperor or the princes appeared prominently, for they would hardly have agreed to sit for their portraits each time one was needed. Pounced copies were also used;

8 Jahāngīr in private
audience with Prince
Parvīz and Prince
Khusraw. By Manōhar,
c.1605–6. 21 × 15.5 cm.
Gouache on paper.
There is a copy of this
painting, perhaps of the
same date, in a Mughal
album in the Institut
Narodov Azii in
St Petersburg.

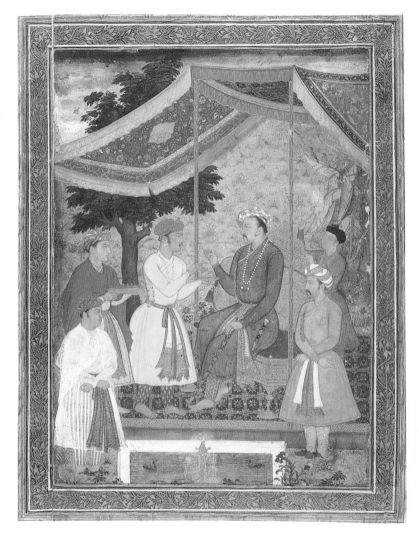

these allowed the outlines of a composition to be reproduced in
their entirety by pricking along the lines to form a 'master' then
dusting charcoal through the holes onto the new page. Once the
outlines had been filled in, the eye of the colourist could achieve a
virtual facsimile: there are many paintings of the periods of Akbar
and Jahāngīr that exist in several copies which are so close that in
order to determine which is the original and which the copy we
must resort to circumstantial evidence.

— 3 —

THE BEGINNINGS OF
MUGHAL PAINTING

The Timurid family tradition with which Bābur so proudly identified himself was passionately devoted to the arts of the book. Under Baysunqur (d.1433) and again under Ḥusayn Bayqara (d.1506), Herat became famous for its painters, illuminators, calligraphers and binders. The specialist organisation of a palace studio or scriptorium to keep up a high rate of manuscript production for an impatient ruler we probably owe to Baysunqur. But in the eyes of Bābur and his contemporaries Herat reached its zenith under Ḥusayn Bayqara and his vizier, the great Chaghatay poet ʿAlī Shīr Nevā'ī, where the scriptorium was headed by the legendary painter Bihzād, whose works even in his lifetime became the criterion by which all other Persian painters were to be judged. The scriptorium broke up at the end of Ḥusayn Bayqara's reign; Bihzād was carried off to Tabriz by the Safavid Shah Ismāʿīl to organise the palace studio there; and other painters were taken to Bukhara by the Uzbek conqueror, Muḥammad Shaybanī. Its fame remained, however, and it was to serve as the paradigm when, later, Humāyūn and Akbar came to found their own scriptoria.

Bābur was himself a connoisseur of painting and inherited the taste of his Timurid predecessors in fifteenth-century Herat. A beautiful *Shāhnāme* or *Book of Kings*, the Persian national epic, made for Muḥammad Jūkī, a grandson of Tamerlane, *c.*1440 and now owned by the Royal Asiatic Society in London, bears Bābur's

seal with the date 906/1501, the year in which he first gained the throne of Samarkand. It evidently reached India in his possession and may well have been the inspiration for the copy of the *Shāhnāme*, now lost, which was ordered by Akbar in 1582. As his memoirs relate, he more than once had to abandon his entire baggage, which would have included a whole library of illustrated books (rulers on campaign in those days equipped themselves even more lavishly for all eventualities than an English family on its way to its summer holiday in a villa in Tuscany). This *Shāhnāme*, though perhaps salvaged at random in the turmoil of retreat, gives us graphic evidence of Bābur's fine judgement.

The commissioning of illustrated works was always an expensive business and demanded a stable residence, which was the one thing Bābur never had. But had circumstances made him ruler of Samarkand, as he so fervently hoped they would, he would certainly have commissioned painting himself and we can even deduce the nature of it. For his memoirs, the *Bābur-nāme*, vividly show a pronounced personal taste, which was to have lasting effects on the Mughals in India, both under Akbar, when the memoirs were illustrated for the first time (*c.*1589–90), and under his great-grandson, Jahāngīr (reigned 1605–27), not only for naturalistic representation but also for natural history.

An interest in naturalism first shows itself in Persian painting in drawings and studies in albums made for the Timurid rulers of Herat and the Turcoman rulers of Shiraz and Tabriz. Though it is still not easy to explain how, their concern for naturalism seems to have been stimulated by Chinese drawings, paintings and textiles, by no means all of the finest quality, brought into Iran and Central Asia, by both land and sea, in the brief period *c.*1405–30 when the Ming emperors were prepared to encourage diplomatic exchanges with the West. With this naturalism came a gradual revolution in the attitude of Muslim authors to painting as such. Despite the common belief that Islam proscribes figural art, many Muslim cultures, particularly in Iran and Central Asia, had long shown what might be called an attitude of conditional tolerance towards figural representation. They had little choice. There was no coherent body of lawyers' decisions to give the painters or their patrons any guidance, even had the painters been prepared to accept it; nor could many of the lawyers have been aware of what their colleagues had opined. In the fifteenth and sixteenth centuries, however, this traditional view underwent a startling change. Echoing Bābur, writers like the mid-sixteenth-century Safavid court librarian Dūst Muḥammad and the Qāḍī (Judge) Aḥmad (*c.*1606), whose father had been in the service of the Safavid prince,

Ibrāhīm Mīrzā at Meshed, in their treatises on painting take as their principal criterion of excellence that paintings should be life-like: that is, the painter gives life to his forms, precisely the grounds on which some of the earlier lawyers of Islam had condemned painting as a blasphemous arrogation of God's creative power.

Bābur's interest in natural history, with which his memoirs are imbued, was even more original, and many graphic passages in the *Bābur-nāme* practically cry out for illustration. One example must do. While approaching a sheet of water near Kabul 'we saw a wonderful thing – something as red as the rose of the dawn kept showing and vanishing between the sky and the water... When we got quite close we learned that the cause was flocks of geese [probably the China goose, not, as might be supposed, flamingoes], geese innumerable which, when the mass of birds flapped their wings in flight, sometimes showed red feathers, sometimes not.'

To the end of his life Bābur never reconciled himself to the loss of Samarkand, and his fixation upon Central Asia was largely shared by his descendants. Though they came to identify themselves solidly with the Indian sub-continent language, family ties, political alliances and Timurid traditions led them to view Afghanistan, and Kabul in particular, as an integral part of their domains. Bābur's often-quoted diatribe against India might seem to be an expression of this nostalgia:

Hindustan is a country that has few pleasures to recommend it. The people are not handsome. They have no idea of the charm of a friendly society, of frankly mixing together, or of familiar intercourse. They have no genius, no comprehension of mind, no politeness of manner, no kindness or fellow feeling, no ingenuity or mechanical invention in planning or executing their handicraft works, no skill or knowledge in design or architecture; they have no horses, no good flesh, no grapes or musk-melons, no good fruits, no ice or cold water, no good food or bread in their bazaars, no baths or colleges, no candles, no torches, not a candlestick.

It must, however, be a literary exercise, not a sober judgement. For, in particular, he concedes the abundance of skilled craftsmanship in India, with a generally hereditary guild or caste system for every sort of work, the like of which he had not seen anywhere else. Whereas, he says, Sharaf al-Dīn ʿAlī Yazdī, one of Tamerlane's encomiasts, had boasted that 200 stone-masons conscripted from the distant lands he had conquered were set to work on the Bibi Khanum mosque in Samarkand, one of the grandest building projects in the history of Islam, on his own building works in Agra

9 Ruler enthroned in a pavilion. *c*.1600. 17.3 × 12 cm. Gouache on paper. The ruler is identified in gold ink as Sulṭān ʿAbdallāh Khān Uzbek, who was governor of Mandu under Akbar in 1562.

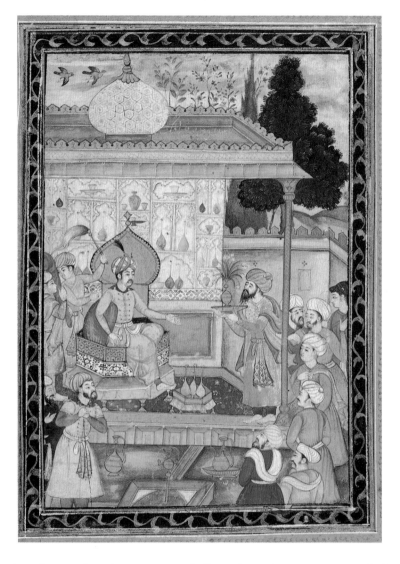

alone he employed 680 masons daily and another 811 masons daily on his works elsewhere.

In many respects Humāyūn was an unworthy successor. His character was weak and debilitated by opium-eating as well as by the traditional Timurid fondness for drink, and the military reverses of the first decade of his reign must in part be attributed to this. However, for the history of Mughal painting no less than for the future of the Mughals in India, his years in Persia were a fortunate coincidence. For in the early 1540s the Safavid Shāh Ṭahmāsp, whose studio in Tabriz was the finest and the most highly specialised in the Islamic world, appears to have had doubts about the legitimacy of commissioning so many beautifully

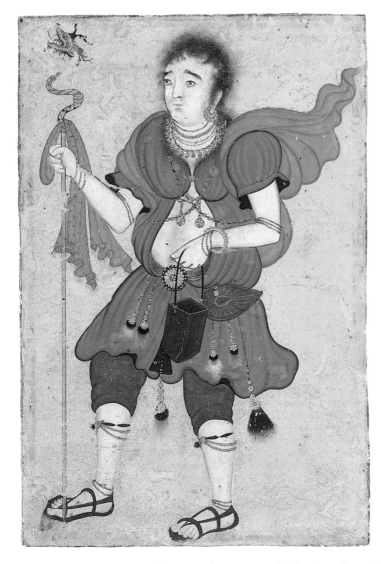

10 Blue-eyed mendicant dervish, with a snake-headed staff. Album leaf, *c*.1570. 19 × 12.8 cm. Gouache on paper. The choice of such a bizarre subject may well have been inspired by albums of paintings and drawings commissioned by the Akkoyunlu rulers of Tabriz in the late fifteenth century.

illustrated manuscripts, at least to the extent of releasing from his service some of the finest painters of his studio. Two of these, Mīr Sayyid ʿAlī and ʿAbd al-Ṣamad (the latter at that stage more reputed as a calligrapher), were opportunely recruited by Humāyūn, entering his service at Kabul in 1549 and accompanying him on his return to India. It was they first and foremost who were responsible for the organisation of the Imperial Mughal studio.

Considering Humāyūn's beleaguered state and the unlikelihood of his ever regaining a stable position in India, the employment of two distinguished and doubtless expensive painters while he was still in exile represented a considerable investment for the future. The credentials they supplied on their arrival at Kabul to join him

11 Jamshīd writing on a rock, a theme probably taken from the *Bustān* of Saʿdī. By ʿAbd al-Ṣamad, dated 1588. 27 × 19.5 cm (inside margins). Gouache on paper. From an album compiled for Jahāngīr, probably before his accession.

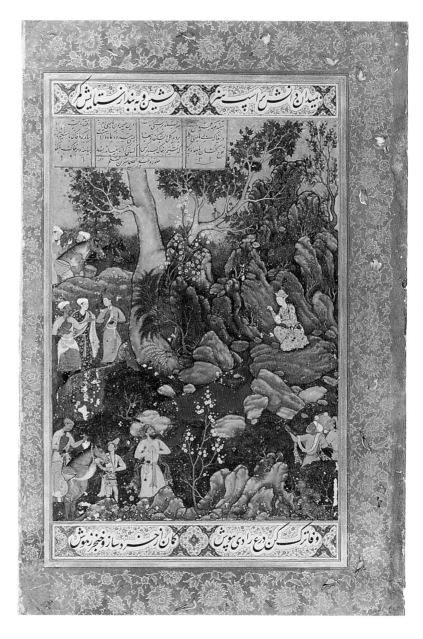

were, moreover, odd. Mīr Sayyid ʿAlī is reported to have executed a scene from a polo match on a grain of rice, with goal posts at each end and horsemen, two in the centre of the field, one galloping in from a corner and a fourth being handed a polo stick by an attendant. Some idea of his figure-painting in less unfavourable conditions is given by a study attributed to him of a Safavid prince and his page done at Tabriz, *c.*1530. ʿAbd al-Ṣamad's calligraphic skill is reported to have been displayed by the last chapter of the

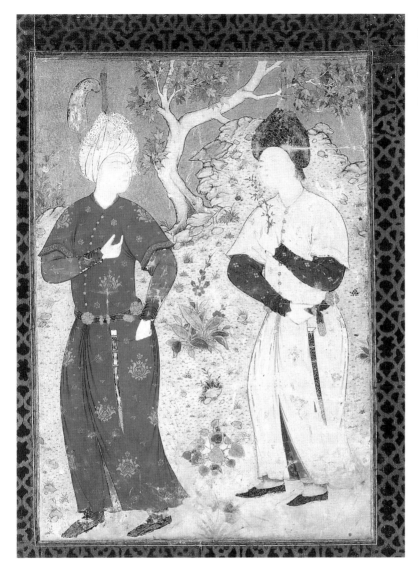

12 Safavid prince and page. Attributed to Mīr Sayyid ʿAlī. Tabriz, c.1530. 43.7 × 30.9 cm (page); 36.4 × 25.8 cm (inside margins). Gouache on silk.

Koran, the *Sūrat al-Ikhlāṣ*, he wrote on one side of a grain of rice, with a commentary to it on the other; but other writers credit him with something similar to Mīr Sayyid ʿAlī's polo scene. A third artist, Mullā Fakhr, a book-binder from Tabriz who was also in their company, was praised for his skill in drilling poppy seeds with minute holes. These were evidently virtuoso accomplishments in which the aesthetic effect could scarcely have counted for much and we may in fact wonder how many of Humāyūn's court had eyes sharp enough actually to descry the details. It is understandable why portraits of painters in Mughal and Safavid art quite frequently show them wearing spectacles (imported from Venice or

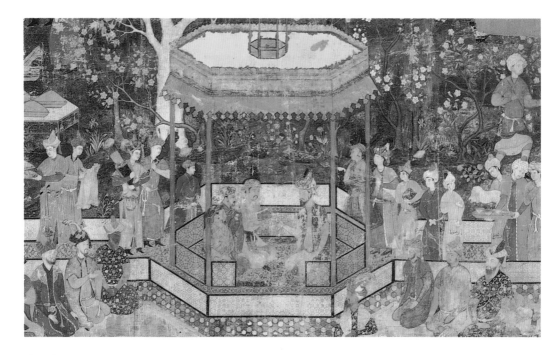

13 'The Princes of the House of Timur' (detail). See fig. 1.

Flanders) and why much of their best work, where datable, is from their early youth. There was evidently a continuing demand for such optical wizardry. Fazūnī Astarābādī reports, for example, that ʿAbd al-Ṣamad presented a mirror-box, evidently a sort of kaleidoscope, to Akbar as late as 1008/1599–1600.

It is not exactly clear how Humāyūn employed ʿAbd al-Ṣamad and Mīr Sayyid ʿAlī in their first years with him, though at Kabul by the 1540s the pavilions and palaces built by his father Bābur would have been beginning to need redecoration and any number of painters would have found ready employment. Little of this decoration has survived, but we know that both the successors of Tamerlane at Herat and Samarkand and the Safavids in Iran gave great importance to depictions of their triumphs in the public rooms of their palaces. Tamerlane himself is said by later historians to have ordered illustrations of his victories and feasts in various palaces built for him at Samarkand. Shāh Ṭahmāsp, much more circumstantially, is even reported to have decorated the Chihil Sutūn palace at Qazvin himself, with scenes including the appearance of Joseph before Potiphar's wife (Zulaykhā), his beauty so ravishing her ladies that their fruit knives slipped and they cut their fingers. Though the extent of his personal initiative may have been flatteringly exaggerated and he may not even have sketched the sort of thing he wanted but merely specified it in detail, till the 1960s traces of these paintings, which were rather small in scale, could

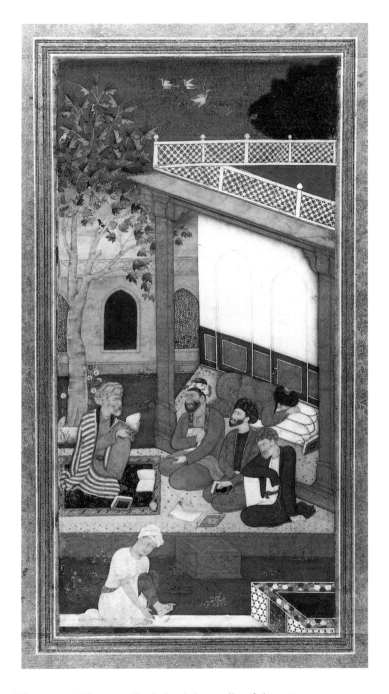

14 Mullahs conversing in a *madrasa*. Album leaf, from the Polier Album. Period of Jahāngīr, *c.*1610. 21.8 × 10.9 cm (painting). Gouache on paper.

still be seen. Akbar similarly had the walls of the private apartments at Fatehpur Sikri decorated by the painters of his studio, but of these the traces are too few to give a proper idea of them.

These paintings were evidently small in scale, not monumental. The effect is well conveyed by a depiction of a court entertainment

now in the British Museum, known as 'The Princes of the House of
Tīmūr', which despite being substantially cut down is still more
than a metre square. It shows a ruler in Central Asian dress seated in
a garden pavilion and evidently receiving a visitor in audience. In
the background are servants and to either side courtiers and
notables are seated. The foreground, now missing, would have
shown a pool with a fountain and, probably, dancers and
musicians. Various later Mughal figures have been painted in,
including Akbar, Jahāngīr and Prince Khurram (who ruled as Shāh
Jahān), while the seated courtiers have been labelled as the sons and
grandsons of Tamerlane. There is no doubt, therefore, that the
reason why the later Mughals added themselves to the painting,
probably one by one, is that they believed it to be a genealogical
scene. It is not certain that their conclusion was justified, for minute
inscriptions, probably original, on some of the figures give quite
different identifications. The central figure, which the later Mug-
hals labelled as Tamerlane, is often said to be Humāyūn. Though
no authentic portrait of him is known, this is certainly very much
how he was shown in Mughal painting of the later sixteenth
century. If, however, the later Mughals were right in seeing it as a
genealogical scene, where is Bābur? He must therefore be the
central figure. Since the figure at his right hand, the place of the
honoured but subordinate guest, has been replaced by the portraits
of later Mughal emperors, we can only speculate: but if the subject
of the painting was to be Humāyūn or one of his brothers received
in official audience, that is where they should have been. Since
Humāyūn, moreover, would never have been painted out, the
figure they replaced must have been one of his brothers.

The landscape and figures are very much in the style of court
painting at Tabriz in the early 1540s and are so different from any
Mughal painting of the later sixteenth century that they must
clearly be attributed to the painters Humāyūn recruited there, ᶜAbd
al-Ṣamad or Mīr Sayyid ᶜAlī, singly or in tandem. Recently
authorities have come to attribute the work to ᶜAbd al-Ṣamad
alone. His signed work in India is highly manneristic, with
contorted landscapes, bizarre colour contrasts and figures so small
that they tend to disappear; but painters of his ability were surely
capable of painting in various styles and ᶜAbd al-Ṣamad's Indian
style must have been a response to Humāyūn's and then to Akbar's
personal predilections. It follows that this great painting, 'The
Princes of the House of Tīmūr', must have been painted before
Humāyūn's triumphant return to Delhi and that it was intended for
one of his palaces in Kabul. It is, therefore, historically of prime
importance, the beginning of Mughal painting.

— 4 —

PAINTING AT THE COURT OF AKBAR

Humāyūn combined bibliophily with his other pleasures, and we are told that it was a fall in his library, which still stands in the Purana Kila fortress in Delhi, which ended his life in 1556. Outside the world of Agatha Christie, libraries have not usually been dangerous places and contemporary chroniclers differ as to whether the cause was incautious piety or intoxication. But the rather cold-hearted chronogram they composed to commemorate the date, which adds up to the Muslim equivalent of 1556, *Pādishāh az bām aftād* ('The Emperor fell from the roof'), anyway suggests that the library was used for other diversions than reading.

A manuscript of the *Zafarnāme* or *Triumphs of Tamerlane* from Humāyūn's library, copied at Herat by Shīr ʿAlī for the Timurid sultan, Husayn Bayqara in 872/1467–68 and with illustrations attributed by some to Bihzād (Garrett Collection, Johns Hopkins University, Baltimore), may well have been acquired by him during his years of exile. There are no known manuscripts made for him in the earlier part of his reign, though it is recorded that in 1551 ʿAbd ʿal-Samad was ordered to execute a portrait of Akbar painting. Album leaves in which he appears could also well have been his own commissions, such as a painting of him with Hindāl Mīrzā in the Berlin album which S. C. Welch has attributed to another Safavid painter, Dūst Muhammad, *c*.1550, who may well have been

15 NEXT PAGE Ilyās (the prophet Elias) preserves prince Nūr al-Dahr from the sea, into which he had been thrown by a div. From the *Hamza-nāme* (*c*.1562–77). 21.8 × 10.9 cm (painting). Gouache on cotton gauze.

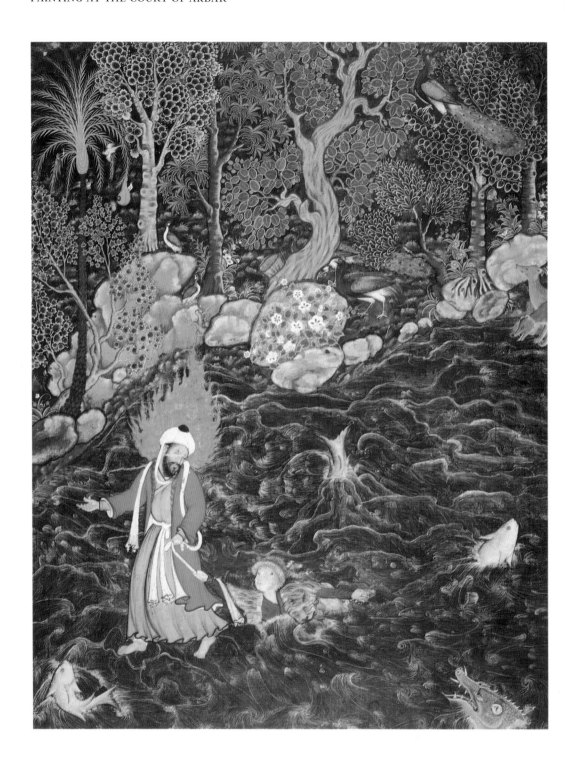

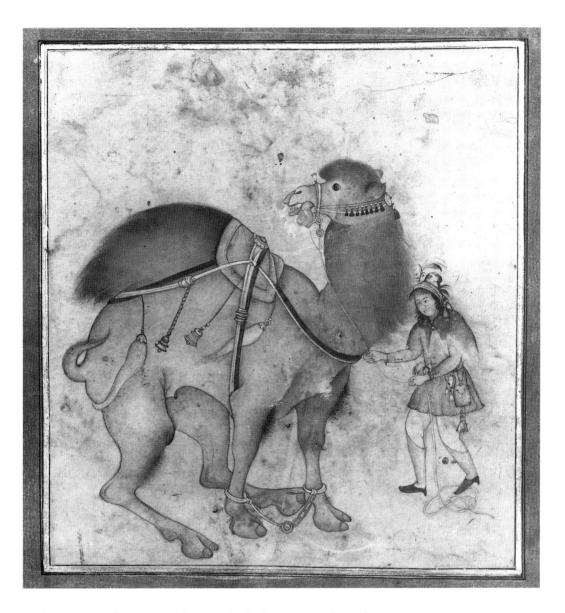

in the service of Kamrān Mīrzā at Kabul. Very much in the same highly mannered style, to judge from a later copy in an album compiled at Lucknow, was a depiction of Humāyūn in a tent.

In the single year of his life which remained once he had regained Delhi, however, Humāyūn must have been too preoccupied with establishing his position to devote himself wholeheartedly to commissioning manuscript painting. The major exception may be a *Ṭūṭīnāme*, a collection of tales narrated by a parrot, now in Cleveland, which he may have ordered before his death, though it cannot have been completed till *c.*1565. This copy is the earliest

16 Camel and its driver. Album leaf, *c.*1600. 14.6 × 13.6 cm (inside margins). Gouache on paper. The subject of this favourite Mughal, Safavid and Ottoman genre-scene goes back to Bihzād in late fifteenth century Herat.

39

17 Young man receiving a cloak from a girl. 24.5 × 18.5 cm. Gouache on paper. From a manuscript, probably made for Akbar, c.1585, of the *Anvār-i Suhaylī* (Lights of Canopus) a florid Persian rendering by Ḥusayn Vāᶜiẓ al-Kāshifī of the fables of Kalīla and Dimna which are ultimately based on the Sanskrit book of fables, the *Panjatantra*. The remainder of the manuscript is now in the Prince of Wales Museum in Bombay.

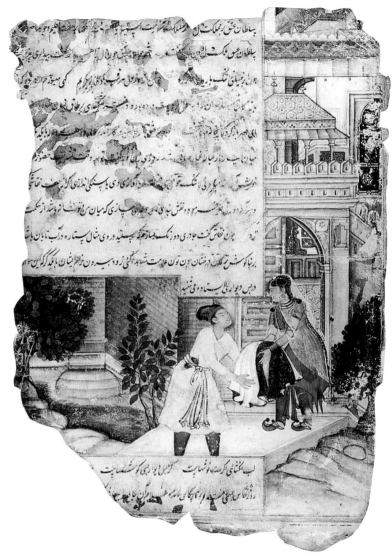

Mughal manuscript so far known to combine elements of the Tabrizi Safavid style, indigenous Hindu or Jain compositions and the traditions of 'Sultanate' painting; but, as is shown by reminiscences of it in later painting for Akbar, for example, a page from a copy of the *Anvār-i Suhaylī* made for him c.1585, it reflects the direction in which the Persian painters Humāyūn had recruited were to adapt their own highly idiosyncratic style to Akbar's taste. Indeed, one of the more marked features of the development of Mughal painting, between the death of Humāyūn and the latter part of the reign of Jahāngīr, is the gradual disappearance of the Persian style, and that despite periodic revivals of it by refugees or recruits from the court of Shāh ᶜAbbās at Isfahan.

17

'Abd al-Ṣamad's portrait of Akbar painting was no mere flattery. Abu'l-Fażl writes in the *Āyin-i Akbarī*, his description of Akbar's court and its workings completed in 1006/1597–98: 'Drawing the likeness of anything is called *taṣvīr* [painting]. Since it is an excellent source of both study and entertainment His Majesty from his childhood has taken a deep interest in painting. A very large number of painters has been set to work. Each week the supervisors and scribes submit to him the work done by each artist and His Majesty rewards them according to their excellence.'

The real begetter of Mughal painting, therefore, was Akbar, which is in one respect ironic since his son, Jahāngīr, and his chroniclers too, report that he was illiterate – though it has more recently been plausibly suggested that he was in fact dyslexic. There are paintings surviving from the first decades of his long reign (1556–1605), including album leaves, like one depicting a bizarrely dressed, blue-eyed, wandering dervish somewhat reminiscent of figure studies in the court albums of the White Sheep Turcomans at Tabriz in the late fifteenth century, now in the library of the Topkapi Saray Museum in Istanbul. But Akbar's first and greatest project was the copying and illustration of a romance already popular in India, the *Ḥamza-nāme*, the heroic exploits of the Emir Ḥamza, a kinsman of the Prophet. This was originally orally transmitted, recited by professional story-tellers and, Badaoni records, in the years following his accession in 1556 the young Akbar loved to recite episodes from the *Ḥamza-nāme* to his harem, for all the world as if he were a professional story-teller himself. It seems appropriate that the first commission of a dyslexic emperor should have been an oral epic.

The oral origins of the *Ḥamza-nāme* go far to account for its inordinate length. Contemporaries differ on the exact number of volumes to which it ran and the number of illustrations in each, but it seems to have been in at least fourteen volumes, each with at least a hundred illustrations. Of this enormous undertaking fewer than a hundred and fifty pages survive, though others may still turn up. It was begun in 1562 (or possibly as late as 1567) and is generally agreed to have taken about fifteen years to complete. Far too few pages remain for us to chart the progress of the work or to identify how the styles of the painters who worked on it evolved over this long period. It does not particularly matter, in fact, whether the fourteen volumes were produced in sequence. It was done on cloth, with a stout paper backing, and its giant format is exceptional in Islamic painting. This has given rise to the supposition that the pages were held up during recitations of the *Ḥamza-nāme* before Akbar to illustrate the narrative. Similar giant-format paintings

18 Noah's Ark, possibly from a manuscript of the *Divan* of Ḥāfiẓ, *c*.1590–1600. 28.1 × 15.6 cm. Gouache on paper. Attributable to Miskīn, a painter particularly admired for his treatments of animals.

19 OPPOSITE The assembled animals complain to the raven of their mistreatment at the hands of man. Album leaf, *c*.1600. 27 × 19.4 cm. Gouache on paper. Attributable to Miskīn. The theme derives from the *Şerefü'l-Insān* by the Ottoman poet Lāmi'ī Çelebi (d. 1538). There is another version of this page, without the brilliant colourism, in the Freer Gallery of Art, Washington DC.

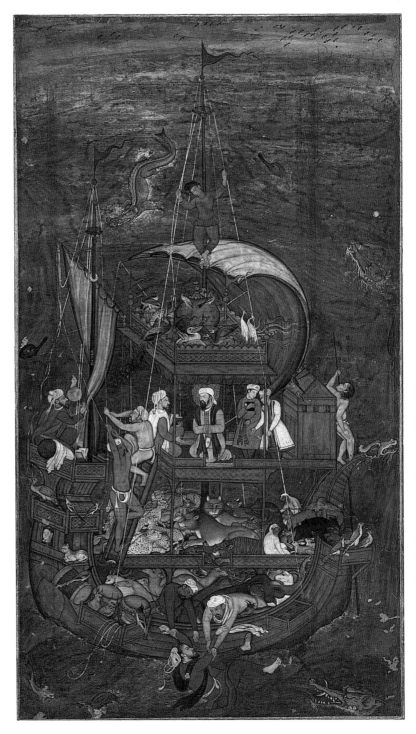

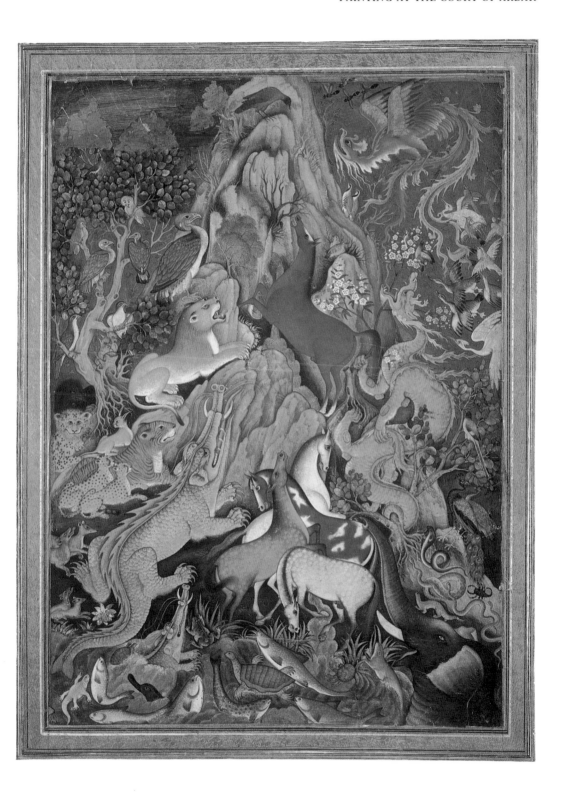

20 Buffalo and mule yoked to the driving shaft of a water-wheel. On the left is a swarm of bees. Possibly by Basāwan, c.1600–10. 6 × 11 cm. Gouache on paper. Cut down from a page of text, perhaps from the *Anvār-i Suhaylī*, or else a vignette from an illuminated margin from an album made for Jahāngīr.

were evidently used like this to illustrate public recitations from the *Shāhnāme* of Firdawsī at the Timurid and Turcoman courts; and, given Akbar's recorded delight in the *Ḥamza-nāme*, public recitals of it would have been most appropriate. This would mean that the volumes were not bound. Because, however, the text is sequential they must each have been planned and executed as illustrated *books*, for the problem of collating such a mass of written sheets would otherwise have been insuperable. The idea of using the paintings in public, therefore, may have been an afterthought.

The colossal scale of the *Ḥamza-nāme* project had momentous consequences. Even had Akbar desired it, it was far beyond the physical capacities of the small staff of Persian painters and their assistants which Humāyūn had assembled. The resultant mass conscription of painters, Hindu as well as Muslim, was a prime factor in establishing the individual character of Mughal painting and was to set the course of evolution in Mughal taste for the rest of Akbar's reign. Though we know little of who actually did the illustrations, even the Muslim painters, for example those from Malwa and the Muslim courts of the Deccan (Ahmadnagar, Bijapur and Golconda), would all have been trained in markedly differing styles and in wall-painting (a probable source for many of the illustrations), possibly not in book-illustration at all. The surviving paintings are, not surprisingly, variable in quality and many must have been experiments without a practical sequel. ʿAbd al-Ṣamad and Mīr Sayyid ʿAlī (who in 1572 departed for the Hijaz) could have

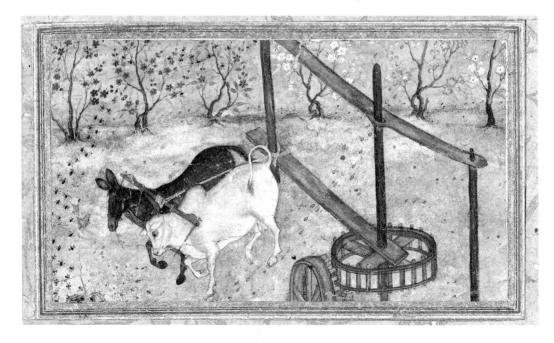

played little active part in their execution, moreover, for they must have had their work cut out in the administration of the studio, obtaining the paper and pigments, issuing them as necessary to the painters and accounting for them to the Treasury, and then seeing that the work was satisfactory and completed on time.

The scenes abound with adventure and drama, giants, monsters and demons, in a smoky palette of colours which was to characterise painting for Akbar almost till the end of his reign. The effect is often brilliant, but bold rather than refined, combining Persian compositions and figures with the dark, jungly landscapes of the painting of pre-Islamic India. Too few illustrations really survive for us to judge their narrative relevance. Up to a point they mirror the text which, like so much oral literature, goes hectically on from incident to incident without too much concern for coherence or consequence. One of the finest of them shows the miraculous rescue of Ḥamza's son, Nūr al-Dahr, from drowning. In it we may detect the work of at least four separate hands: the water, painted in bravura linear style with white highlights; the figures; the forest landscape and some or all of the birds.

The amazing corpus of extant Mughal painting from the reign of Akbar shows him to have been one of the most active and involved patrons of the arts of the book in history. Some of his commissions were illustrated works which would have found a place in any palace library, astronomical and astrological treatises, particularly star books; herbals and other works relevant to medicine; works of cosmography and geography, though relatively few of these have survived; or treatises of theology and law, often rendered more palatable to a royal owner by illustrated anecdotes. Such is a copy of Jāmī's *Nafāḥat al-Uns*, a collection of potted biographies of the saints and Sufis, prophets and patriarchs of Islam, made for him in the forty-ninth regnal year (1603). Others were manuscripts collected as loot or presented to him as tribute. These were often incomplete, with blanks for illustration, and several fifteenth-century Persian or sixteenth-century Bukhara manuscripts completed with fine miniatures to Mughal taste are known.

Yet others were the classics of Persian and Turkī literature: the *Dīvāns* (collected works) of Ḥāfiẓ or Saʿdī; the *Khamsa* or five romances of Niẓāmī; the Persian national epic, Firdawsī's *Shāh-nāme* or *Book of Kings*; the poems of the Timurid vizier, ʿAlī Shīr Nevāʾī, who virtually created Turkī as a literary language; and the romances of Delhi's most famous poet, Amīr Khusraw Dihlavī, whose tomb at the khanqah of Niẓām al-Dīn in Old Delhi is still a place of pilgrimage. Amongst all these one genre is conspicuous, books of fables based upon the *Kalīla wa Dimna* cycle (which itself

21 Hunt with a leopard being skinned.
35.5 × 22 cm. Gouache on paper. From the manuscript of the *Anvār-i Suhaylī* copied for Akbar and dated 22 Rabīᶜ II 978/ 23 September 1570.

22 OPPOSITE The Sufi mystic, Abu'l-Adyān, praying in a fiery furnace before an audience of admiring Zoroastrians and giving proof that even fire submits to the will of God. By Dawlat. 25 × 13 cm. Gouache on paper. From a manuscript of Jāmī's *Nafāḥat al-Uns*, potted biographies of saints and famous Sufis, made for Akbar in the forty-ninth regnal year/1603.

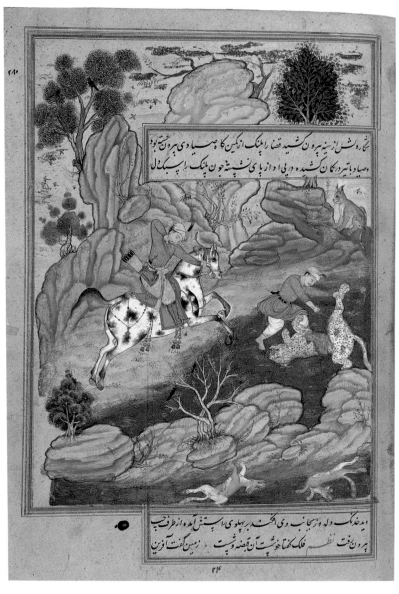

was based on the Sanskrit *Panjatantra* of Bidpai) – the *Anvār-i Suhaylī* (*Lights of Canopus*) by Ḥusayn Vāᶜiẓ al-Kāshifī and a simplified version of that made at Akbar's command, the *ᶜIyār-i Dānesh*. The earliest copy of the *Anvār-i Suhaylī* made for him is dated 978/1570–1 and shows marked reminiscences of contemporary painting at Tabriz or Meshed. It contains twenty-seven full-page miniatures, but the margins of some of the other pages have pounced sketches in charcoal, surprisingly smudgy, however. Like the ruled margins of some of the pages intended for illustration, which bear little relation to the format of the paintings, they could

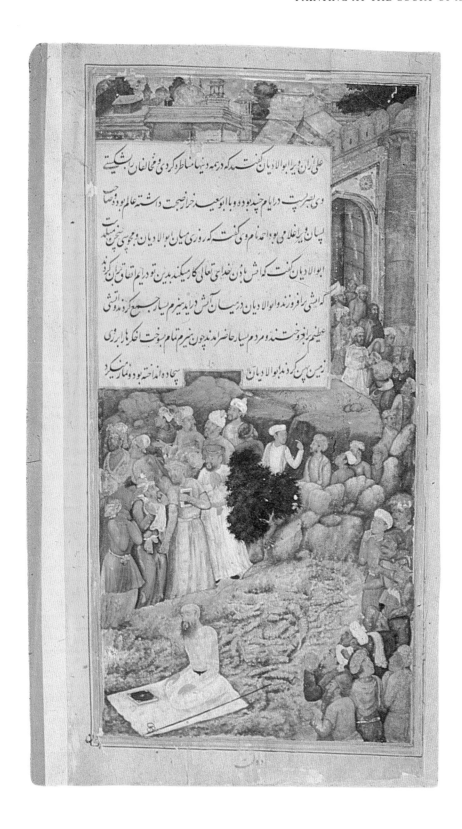

23 Krishna as a
cowherd. *c.*1580–90.
30 × 20.5 cm. Gouache
on paper. From a
dispersed manuscript of
the *Harivamsha*.

have been afterthoughts, indicating that the strict co-ordination in
the studio between calligraphers, painters and illuminators neces-
sary for the luxury manuscripts made for Akbar later in his reign
had yet to evolve.

The expenditure of time and labour on the illustration of the
Ḥamza-nāme had in a way less of a concrete effect on the illustra-
tion of these various works than one would expect, for neither in
format nor in style do most of them compare with it. It is almost,
therefore, as if it had been seen by Akbar's studio as a practice run
in organising a vast body of painters for the traditional work of a

24 Christ's entry into Jerusalem. 14.8 × 7.3 cm. Gouache on paper. An illustration (c.1602) to the *Dastān-i Masīḥ* (the Life of Christ) which was composed by the Jesuit Fr. Jerome Xavier and presented to Akbar in 1682.

royal scriptorium – though in Akbar's case, with the all-important addition of non-Muslim classics too. Akbar's subject population was very largely non-Muslim, being Hindu, Jain, Christian or Zoroastrian. The consolidation of his Indian empire, which was more or less complete by his death in 1605, had been accomplished not only by military victory but also by peaceful means, alliances and dynastic marriages with the rulers of North India. Mere prudence would, therefore, have favoured toleration of Hindus (who not being People of the Book were *a priori* excluded from the statutory toleration accorded in an Islamic society to Christians,

25 A gigantic bird with a man in its claws and a fortress full of amazed Europeans, from the tale of the maiden of the First Clime in the *Haft Paykar*, one of the five books of Niẓāmī's *Khamsa* which was copied for Akbar at Agra in 1595. By Dharmdās. 30 × 19.5 cm (page). Gouache on paper.

26 OPPOSITE Bābur admiring the rock-cut Hindu sculptures at the base of the fortress of Urwa near Gwalior, which he visited in September 1528. *Bāburnāme, c.*1590, 28.2 × 15 cm. Gouache on paper. Though Bābur recounts that he ordered the destruction of the sculptures, the illustration is still psychologically accurate, for they were subjected to only slight defacement.

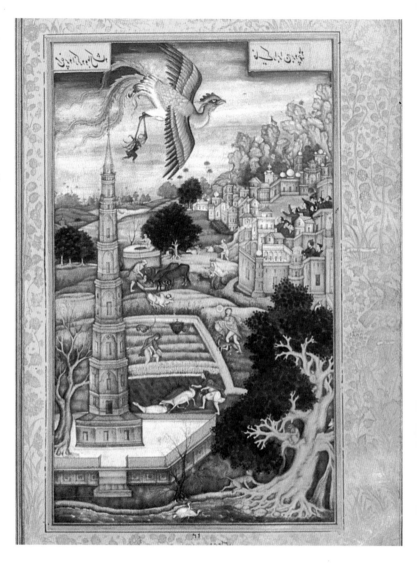

Jews and Zoroastrians); though if prudence was Akbar's principal motive he was somewhat exceptional among his contemporaries in Europe and Asia.

However, in a remarkable way, he was sincerely eirenic. In 1564 he abolished the *jizya*, the traditional Muslim poll-tax on non-Muslim subjects, and, in the decade following his proclamation of the Dīn-i Ilāhī in 1579, which claimed to unite the religious truths of Islam, Christianity and Hinduism, he ordered a series of illustrated Persian translations of Hindu, and later Christian, religious works. These were not merely for himself but also for his officials and generals, to enlarge their sympathies. They are a phenomenon peculiar to Mughal culture, and peculiar, indeed, to Akbar's reign.

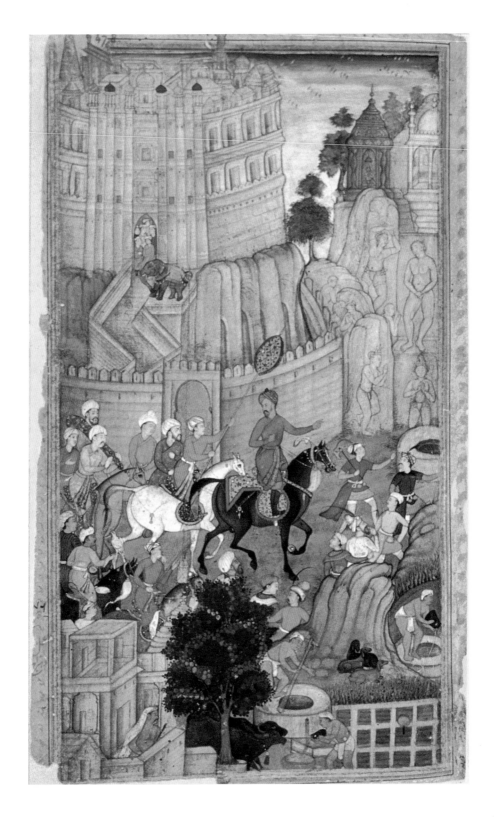

Like the Dīn-i Ilāhī itself they were much contested by his advisers, but Akbar's policy was not without result. For example, ʿAbd al-Raḥīm, Khān-i Khānān, later Jahāngīr's commander-in-chief, eventually commissioned a copy of the *Razmnāme* or *Book of Wars*, his Persian translation of the Hindu epic, the *Mahābhārata*, for his own library.

Apart from the *Mahābhārata*, which took two years or so to complete (1582–4) and which was illustrated several times, the translations included the *Ramāyana*, the *Harivamsha*, begun in 1585, and the *Jog-Bashisht* (a much condensed version of a Sanskrit text on the instruction of Rama in Vedanta theosophy by the sage Vasistha), as well as, under the influence of the Jesuit mission to Agra of 1580–3, a life of Christ by Fr. Jerome Xavier, the *Dastān-i Masīḥ* (cf. fig. 3). Islam, however, also got its due. To commemorate the completion of the first millennium of Islam (1000/1591–2), Akbar commissioned the *Tārīkh-i Alfī* or *History of the Millennium*, represented in the British Museum's collection by a page showing the mid-ninth-century ʿAbbasid Caliph, al-Mutawakkil, destroying the tomb of Ḥusayn at Kerbela and other incidents of his reign. He also gave importance to illustrated dynastic or family histories, in ascending order of magnificence: a history of the Timurid and Mongol rulers (*Tārīkh-i Khāndān-i Tīmūriyya*, the text of which was completed *c.*1584); a history of Jenghis Khan, the *Chingiskhān-nāme*, based upon the *World History* of the early fourteenth-century Mongol vizier, Rashīd al-Dīn (cf. Frontis.); the memoirs of his grandfather, Bābur, or *Bābur-nāme* (illustrated *c.*1589); and a chronicle of his own reign, the *Akbar-nāme* (probably completed in 1590). The presentation copy of this last work is represented by folios in the Victoria and Albert Museum. A more complete copy in the Chester Beatty Library in Dublin may also have been an Imperial commission, possibly *c.*1602 following the murder of his chronicler, Abu'l-Fażl.

The translations made considerable demands on the linguistic skills of Akbar's officials. Pressure was increased by a change during his reign from Eastern Turkish (Chaghatay or Turkī) to Persian as the court language. This made it necessary to translate even Bābur's memoirs and the task was completed, probably in 1589, under the direction of the ever-obliging ʿAbd al-Raḥīm, Khān-i Khānān. No fewer than four major copies of the *Bābur-nāme* appear to have been illustrated at Akbar's command, the earliest of these, now dispersed but represented by folios in the Victoria and Albert Museum, being a presentation copy for Akbar. Many of the same painters who worked on it also contributed to a fine copy (*c.*1590) now in the British Library (Or. 3714), in which

27 OPPOSITE Destruction of the tomb of Ḥusayn at Kerbela by order of the ʿAbbasid Caliph al-Mutawakkil (d. 861 AD) and other events of his reign. From a dispersed manuscript of the *Tārīkh-Alfī* (History of the Millennium), commissioned by Akbar to celebrate the year 1000 of the Hijra (1591–2). *c.*1590. 40.2 × 22 cm. Gouache on paper.

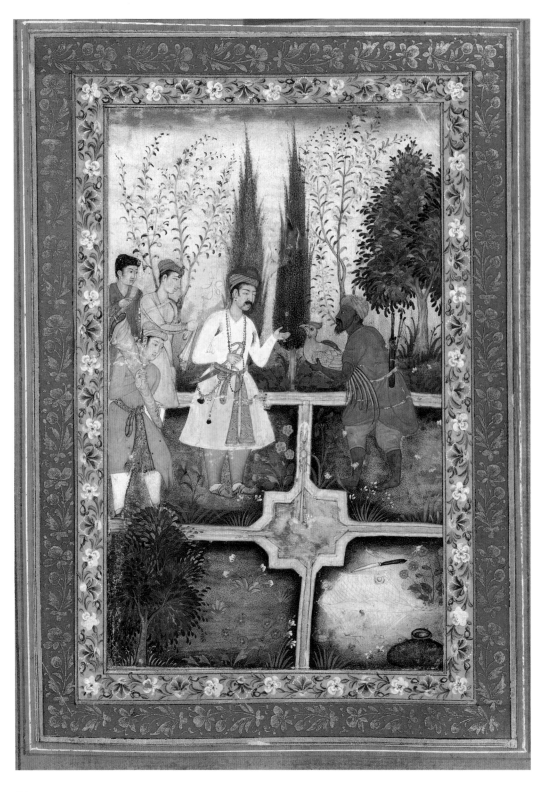

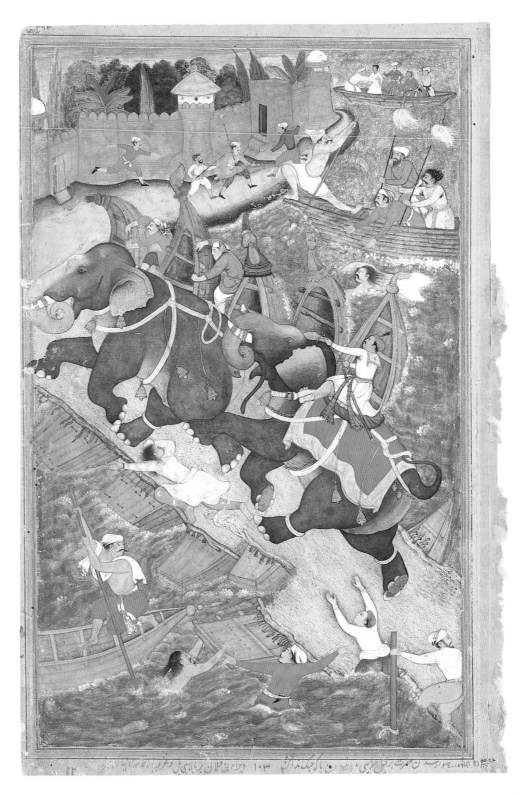

28 PAGE 54 Prince in a garden, presented with a jungle-fowl, probably an illustration to a lost episode of the *Bāburnāme*. *c*.1590. 15.3 × 9.5 cm. Gouache on paper.

29 PAGE 55 Akbar tames the savage elephant, Hawā'ī, outside the Red Fort at Agra. Left hand page of a double-page miniature. By Basāwan. *Akbar-nāme, c*.1590. 34.5 × 21.7 cm. Gouache on paper.

a total of fifty-four painters' names, including Manōhar and Manṣūr, are to be found. Many of the illustrations in these copies are double-page spreads. They show episodes from Bābur's campaigns, his visits to his relatives, his feasts, his hunts, 28 and the gardens he ordered, particularly near Kabul. Others, how- 2 ever, are of the flora and fauna of India and are cameos, often three or four to a page. The subjects for illustration, like Bābur's visit to the rock-carved idols below the fortress of Urwa, were evidently 26 deliberately chosen to illustrate Bābur's wide sympathies, which Akbar himself shared.

The *Akbar-nāme* was written as panegyric and accordingly lacks much of the psychological acuity of Bābur's recollections, but the surviving copies of it give, both in the narrative and in the illustrations, a picture of Akbar's life and times which is remarkable for its minute detail. From it we can even recreate the splendour and 29 ceremonial of his court at Fatehpur Sikri, the red sandstone city he founded near Agra with its beautiful but now enigmatic monuments which mark a climax of every visit to Northern India. The *Akbar-nāme* illustrations, in this as in much else, are not merely entertaining but are of unique documentary value, for after 1585 Akbar's interests were diverted to other residences and the slow decline of Fatehpur Sikri into the mists of archaeology began. Despite the strong Turkish-Mongol dynastic bias reflected by Akbar's commissions, and the Persian origins of the painters supervising the palace studio and their ready access to Persian and Central Asian manuscripts, which figured largely among their prototypes, the style of these illustrations, allowing for the personal idiosyncracies of the draughtsmen, owes little to the Timurid and Safavid tradition. Primary colours are rare and there is a vast spectrum of smoky tones; figures are highly modelled; and through *sfumato* and other essentially European devices to convey distance, painted landscapes recede towards the horizon almost as if the painters had been trained in Northern Europe. The European effect, indeed, is so striking that when it does not quite come off it is difficult sometimes to decide whether that was accident or design.

Indisputably the finest illustrated manuscript made for Akbar and one of the finest of all Islamic manuscripts is a *Khamsa* of Niẓāmī dated Adhār of the fortieth regnal year (December 1595) at Agra (now in the British Library, Or. 12,208). It boasts an elegant lacquer binding, margins illuminated in gold inks of contrasting tones with an almost infinite variety of detail, magnificently illuminated medallions and head-pieces and forty-four illustrations attributed to the finest masters of his studio, of which forty-two survive, together with a miniature depicting the scribe ʿAbd al-

Raḥīm, ʿAmbarīn Qalam, and a self-portrait of the painter Dawlat added on 14 Shawwāl 101[8]/10 January 1610 at Jahāngīr's insistence.

The range of its illustrations is exceptional and many are difficult to parallel in other manuscripts of Niẓāmī's *Khamsa*. The well-known digression in Niẓāmī's version of the Alexander Romance, in which the painters of Byzantium (Rūm) dispute for mastery with those of China (Chīn), is enlivened by a miniature, by Sūr Gujārātī, of Mānī (the founder of the Manichaean heresy, who in Islamic legend was a painter of miraculous talent) with an interesting array of painter's tools painting a dead dog, virtually a dissection of the animal, on the cover of a polluted well so that people should not lower their pitchers into it. The narrative of the Alexander Romance also contains an illustration (folio 298a) of the philosopher Plato enchanting the animals as he plays a European organ, the case of which appropriately shows Orpheus, or Majnūn, the tragic Persian lover, comforted by the animals. The fact that Plato's animals are obviously dead may well be the painter Maddū Khānezād's satirical commentary on the wheezing and hissing sounds made by the Portuguese organs sent out, doubtless at the Jesuits' suggestion, for Akbar's amusement.

Standard subjects, however, are also treated exceptionally. Bahrām Gūr hunting gazelles, by Mukund (folio 19a), is shown with a background of a Flemish seascape with ships and mountains distantly sunlit. The shaykh (folio 23b, by Miskīnah) swooning away for love of a cruel Christian maid is doing it in style in an alcove decorated with European paintings of Tobias and the Angel, a Sybil with an attendant, and Susanna in the bath, or something even lewder, perhaps the painter's commentary on the moral depths to which his subject had sunk. As for the Phoenix amazing Franks in a fortress (folio 195a, by Dharmdās), this combines an Islamic theme well known from the story of Sinbad the Sailor and other popular sources with the Icarus theme as treated in sixteenth-century Northern European cabinet painting. In all these it is pertinent to remember the talent of ʿAbd al-Ṣamad and Mīr Sayyid ʿAlī for paintings on an almost ridiculously minute scale. In the 1595 *Khamsa*, Dharmdās and his colleagues show themselves worthy pupils to their masters.

Though painting at Akbar's court was so rich and diverse that it is difficult to single out one aspect, portraiture demands special consideration. Its importance naturally owes much to the promin-ence of illustrated chronicles and narrative history in Akbar's commissions. Historical narratives had been illustrated since the early fifteenth century under the successors of Tamerlane, but

30 NEXT PAGE Final colophon of the *Khamsa* of Niẓāmī, dated 40 Adhār of the fortieth regnal year of Akbar. To this was added in the fourth year of Jahāngīr's reign a depiction of the Imperial studio with portraits of the scribe, ʿAbd al-Raḥīm, ʿAmbarīn Qalam, and the painter, Dawlat, and the date 14 Shawwāl 101[8]/ 10 January 1610. 30 × 19.5 cm (page). Gold and gouache on paper.

31 NEXT PAGE Seated prince in Persian costume, reading. Album leaf. Speculatively identified in the margin as Bābur. Perhaps by Āqā Riżā, c.1605–10. 18.2 × 11.3 cm. Gouache on paper.

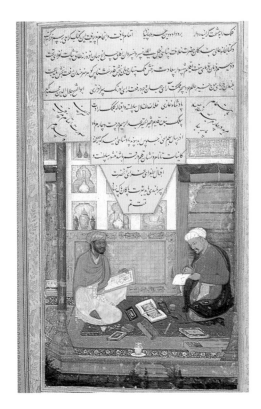

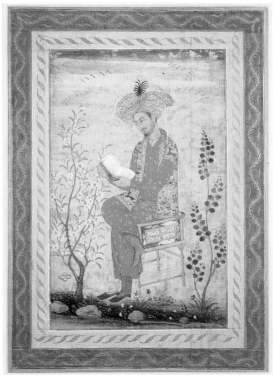

32 OPPOSITE Humāyūn in a tent. Album leaf. 31.7 × 21 cm (inside margins). Gouache on paper. Seventeenth century copy after a Tabriz painting in the manner of Dūst Muḥammad of *c*.1550. Lucknow album. Provincial Mughal (Oudh). The Berlin album compiled for Jahāngīr contains a page showing Humāyūn with Hindāl Mirza, *c*.1550, in a very similar style. That has been attributed by S. C. Welch to Dūst Muḥammad, who was evidently working at this time for Mīrzā Kamrān, Humāyūn's brother, at Kabul.

despite his heroic status in their eyes, there are no known portraits either of him, or of his son Shāh Rukh, of his grandson Ulugh Beg, or of Bābur. Even Humāyūn, who continues to be identified in later sixteenth-century Mughal painting by his characteristic turban, may be a portrait type rather than an actual likeness. This reticence is understandable, for portraiture in Islam is a late development. Among the Mughals' Muslim contemporaries, the Ottomans had been the first to accept portraiture, and Meḥmed the Conqueror (1451–81) had been painted both by Italian artists like Gentile Bellini and by artists from his own studio. In Iran also, at least by the 1530s, court painters were producing albums of portraits of Shāh Ṭahmāsp's officials and notables, and it may even be that the rulers and courtiers depicted in the pages of the famous *Shāhnāme* completed for him *c*.1525–35 (now known as the Houghton *Shāhnāme*, after the man who broke it up) were intended to be portraits too. From these beginnings there gradually evolved a conception of the dynastic portrait, no less for the dynastic histories of the Mughals and the Ottomans than, in Akbar's case at least, for the public audience halls of his palaces. Portraits of him are generally in profile or half-profile and would have been reproduced by stencils, though there are clear signs that, like the images of

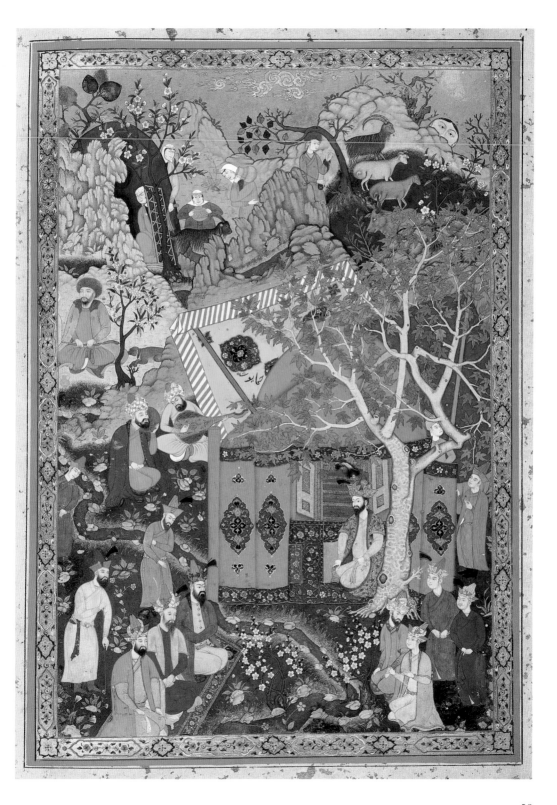

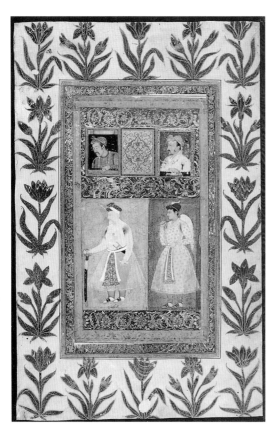

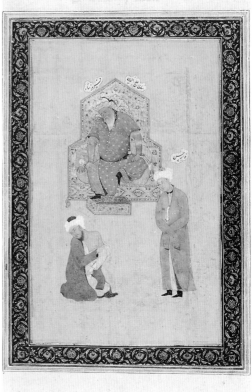

33 ABOVE LEFT Album-leaf with portraits: a bust of Akbar at the audience window (3.8 × 2.7 cm); a bust portrait of Jahāngīr (3.8 × 2.7 cm); a standing portrait of ʿAbd al-Raḥīm, Khān-i Khānān (9.8 × 5.6 cm); and a page with a fly-whisk (9.8 × 4.5 cm). Period of Jahāngīr (1605–27). Gouache on paper.

34 ABOVE RIGHT Imaginary portraits, including the Delhi Sultan, ʿAlā al-Dīn Fīrūzshāh enthroned. Early seventeenth century. 13.4 × 20.8 cm. Ink and gouache on paper.

Queen Victoria on coins of her reign, they were brought up to date as the emperor aged or changed his appearance. The dynastic significance of portraiture increased under his successors and their portraits are thus comparable in function to portraits of the Mughals' contemporaries, Elizabeth I and James I, which they had painted for themselves. As Abu'l-Fażl also relates, Akbar ordered portraits to be made of all the grandees of his realm and placed in an immense album, 'so that those who have passed away have received a new life and those who are still alive have immortality promised them'. In fact, differences in format of Akbari portraits suggest that there may have been several such albums; alternatively, those portrayed in it had copies surreptitiously made for themselves.

The portraits are sometimes stiff, though they include not only male grandees but women, musicians, entertainers and physicians as well: in some respects they could be regarded as refined passport photographs, as much a ready means of identification or reminders as works of art. Akbar's admittedly somewhat sophistical justification of this is most remarkable. Once in a private discussion of painting he remarked to Abu'l-Fażl:

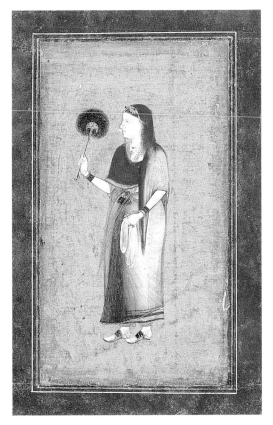

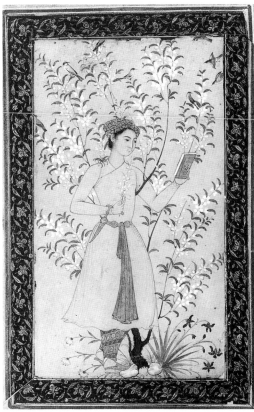

There are many that hate painting, but such men I dislike. It appears to me as if a painter had a quite peculiar means of recognising God; for a painter in sketching anything that has life, and in devising its limbs, one after the other, must come to feel that he cannot bestow individuality upon his work, and is thus forced to think of God, the giver of life, and will then be increased in knowledge.

In other words, painting is practically mandatory in moral education: it is difficult to think of a more total reversal of the disapproval of figural representation characteristic of certain Muslim cultures.

It was not only the Mughals' conception of portraiture which brought them close to their European contemporaries. In Akbar's studio European art enjoyed exceptional importance, as it was also to do under Jahāngīr. This is how it came about. The Mughals' alliances and geographical position linked them not only with the Uzbeks in Central Asia and the Safavids in Persia, but also, both directly and indirectly, with Europe. A principal, if inconstant, ally

35 ABOVE LEFT Standing woman with a fan. *c*.1620–35. 11.1 × 6.4 cm. Gouache on paper.

36 ABOVE RIGHT Youth with a book. Album leaf. Attributed to Āqā Riżā Haravī, the father of Abu'l-Ḥasan, *Nādir al-Zamān*. Early seventeenth century. 15.3 × 8.9 cm. Gouache on paper.

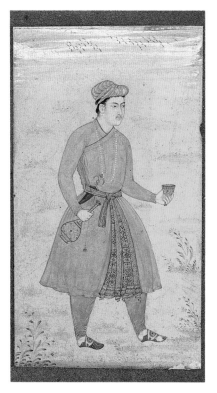

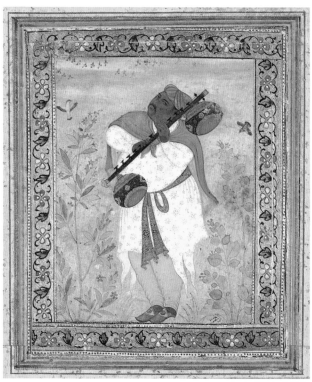

37 A cupbearer. *c.*1610. 11.4 × 6.5 cm (inside margins). Gouache on paper.

38 Portrait of the court musician ʿAlī Khān Karūrī. *c.*1600. 9 × 7.3 cm. Gouache on paper. Signed by Manṣūr, who is most famous as a painter of natural history.

39 OPPOSITE Akbar enthroned as a young man. From a copy of the *Gulistān* of Saʿdī made at Bukhara in 975/1567–8, completed at the Mughal court in *c.*1600–10, when many of the faces were altered to Mughal taste. 34 × 22 cm (page). Gouache on paper.

of both Akbar and Jahāngīr was Shāh ʿAbbās I (1587–1627). His grand aim was to scupper the Ottomans, his mortal enemies, by diverting the highly lucrative overland trade from the East to Northern Europe to the sea route round the Cape of Good Hope. To this end he invoked the European powers, successfully dislodging the Portuguese from the Persian Gulf in favour of the Dutch and the English. The early seventeenth century saw first English and then Dutch factories established in Mughal territory. Despite the rise of Dutch shipping, however, the Portuguese enclaves in Gujarat, chiefly Diu and Surat, and the great port of Goa further to the south remained the principal entrepôts for the Mughals' international trade. Westwards this was very largely spices, drugs and fine woven or printed cottons (tea is not even mentioned in bills of lading or lists of diplomatic gifts till the 1660s); in return came bullion, china-ware (from Southern Persia, for the Mughals had no pottery of their own to supplement the porcelains they imported from China at great price), curiosities for the Mughal court and even ideas (though these must partly have been curiosities too). The curiosities were numerous and diverse, including a turkey-cock which reached Akbar's court in 1577; an organ which arrived in 1581; a state coach brought out to Jahāngīr by Sir Thomas Roe, the

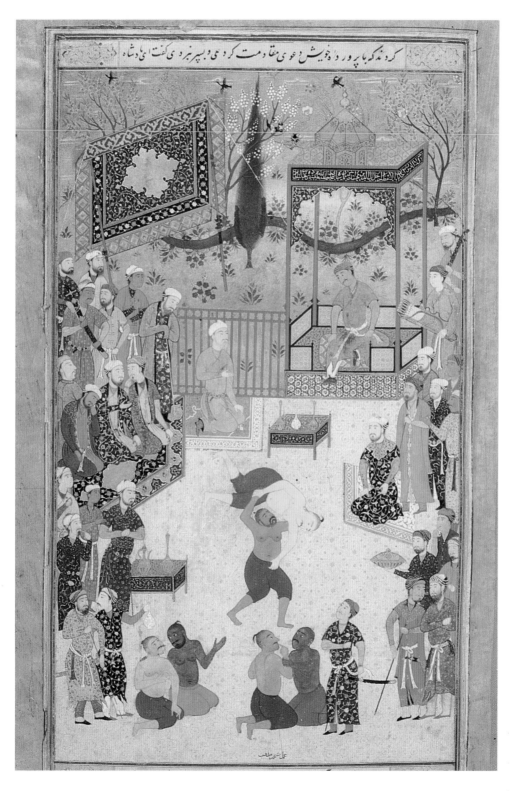

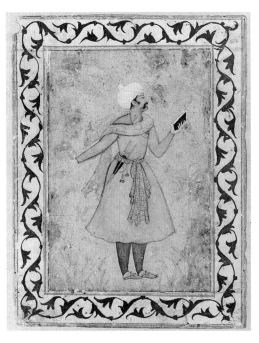

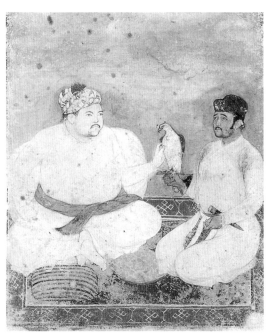

40 ABOVE LEFT
A messenger. *c*.1610.
13.5 × 9.4 cm (inside
margins). Gouache and
gold ink on paper.

41 ABOVE RIGHT Mughal
prince and courtier.
c.1600. 14.1 × 11 cm.
Gouache on paper.

42 OPPOSITE Picture of a
turkey-cock brought to
Jahāngīr from Goa in
the seventh year of his
reign (1612). *c*.1612.
13.2 × 13 cm. Gouache
on paper. Signed by
Manṣūr. From the
Wantage Album.

ambassador of James I of England; clocks, watches and automata;
and masses of Venetian mirrors, mostly so badly packed that they
arrived in bits – which were ingeniously mounted by Indian
craftsmen as mosaics to enliven stucco ceiling and wall decoration.
Their cultural significance was probably not very great. All
contemporary European courts had similar toys providing ephem-
eral amusement on their first appearance but rapidly tired of and
therefore relatively uninfluential: the turkey, for example, may
soon have graced Akbar's table. But the European paintings and
engravings which also came out were a different matter altogether.

Practically from the outset of Akbar's reign, European prints by
Flemish masters working ultimately under the influence of Albrecht
Dürer were accessible to the painters of his studio. An Old
Testament print of Joseph telling his dream to his father by Georg
Pencz (1544) was used by Basāwan in the Cleveland *Ṭūṭīnāme*, so it
must have been in India by the early 1560s. The extreme popularity
of this engraving with Mughal artists may initially indicate a
generalised taste for European religious prints without the means to
gratify it; but following a two-year Mughal mission to Goa in 1575
in search of rarities and the arrival of the Jesuit mission at Akbar's
court in 1580, a trickle became a flood. The prints were acquired by
the Jesuits in Antwerp in the Spanish Netherlands where they took
ship; here the engravings of Albrecht Dürer and his circle were
regularly reprinted. Illustrated bibles, notably the *Thesaurus*

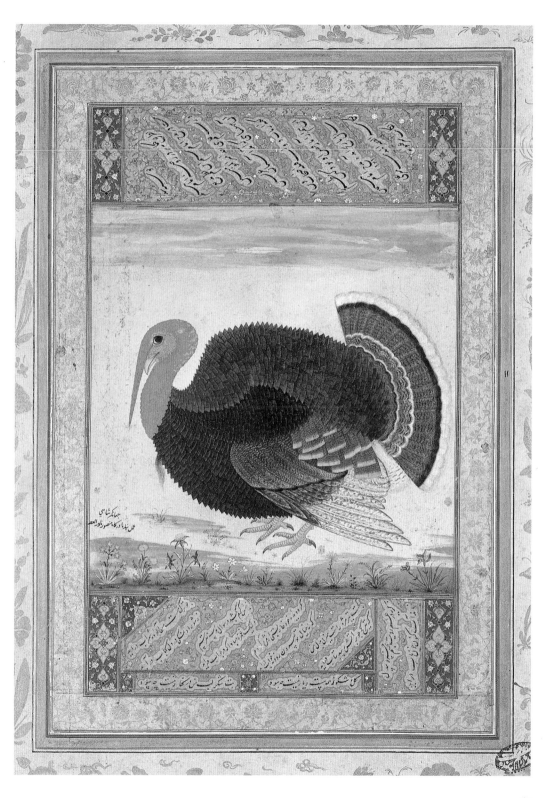

43 OPPOSITE Europeans in a garden. Album leaf. Period of Jahāngīr (1605–27). 18 × 13.2 cm. Gouache on paper. The composition is probably based on an engraving of Diana and Endymion, but has been copied tongue-in-cheek.

sacrarum historiarum Veteris Testamenti (Antwerp, 1585) and Nadal's *Evangelicae historiae imagines* (Antwerp, 1593) also arrived, as well as prints by contemporary Flemish artists, including Aegidius Sadeler, Jerome Wierix and Cornelis Cort. There is some evidence that Dutch, French and Italian prints were also available, though Dutch engravings do not seem to have been important before 1620 or so.

This was not the passivity of the Orientalists' East in the face of aggressive European penetration, as, arguably, occurred in Persia in the eighteenth and nineteenth centuries, but active collecting. The Mughals had, for example, inherited a tradition of line drawings from the Timurids and the Safavids for which engravings were to serve as a most suitable model: like a charming Madonna and Child after Bernart van Orley executed for Jahāngīr *c*.1600 while he was at Allahabad. They not only adopted subjects, however; they adapted their style – sometimes, indeed, with startling results. An extraordinary example of this, signed by one of Akbar's and Jahāngīr's most idiosyncratic painters, Farrūkh Beg, who had worked on the first *Akbar-nāme* but who had then spent some time painting in the Deccan, shows an elderly ascetic in his study with all the apparatus of a Flemish interior, after an engraving entitled 'Dolor' ('Grief') from a series on the Virtues and the Vices which was ultimately based on a St Jerome by Dürer. Although Farrūkh Beg has made not the slightest attempt to disguise his model, the result, with its luxuriant foliage, exaggerated gestures and brilliant setting, is a work of mannerist art in its own right. What is, however, rather difficult to explain is the use of colour, not merely of space, in a recognisably European way, for that could hardly be gained from a black and white engraving.

One possible explanation is that Akbar's painters learned their use of colour directly from European paintings. Though, as we shall see, this is the least likely, both Akbar and Jahāngīr almost vied with the Habsburg emperor Rudolf II in their taste for European paintings of religious subjects, showing them, moreover, such reverence that the Jesuits were led, mistakenly as it turned out, to believe that they were ripe for conversion. Copies of famous Roman Madonnas, in Santa Maria del Popolo, Santa Maria Maggiore and the Lateran were brought out to Agra and Fatehpur Sikri at their express command and were then publicly displayed. William Finch, who was in India in 1608–11, tells us that in Jahāngīr's public audience halls (the Dīvān-i ʿĀmm) at both Agra and Lahore, in addition to portraits of himself, his brothers and his sons there were also pictures of Christ and the Virgin. We do not know what his Muslim officials thought of that, but they may not

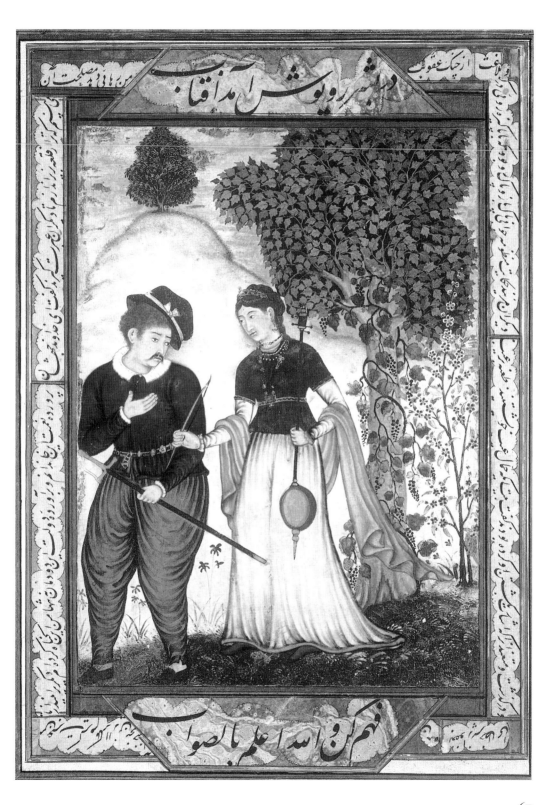

44 The Crucifixion. Album leaf, after one or more European engravings. 19.5 × 17.8 cm. Gouache and ink on paper. Possibly by Kesū Dās, listed by Abu'l-Faẓl as one of Akbar's finest painters, to whom is attributed another Crucifixion of *c.*1590 in the Gulshān album in the Gulistan Palace, Teheran. The heavily modelled figure of Christ may well be after a crucifix. Cf. M.C.Beach, 'The Mughal painter, Kesū Dās', *Archives of Asian Art* xxx (1976–7) 34–52.

45 OPPOSITE Old man drowsing in his study. Folio from an Imperial album. Inscribed *the work of the Wonder of the Age, Farrukh Beg, in his seventieth year* and dated to the tenth regnal year of Jahāngīr (1615). 38.2 × 25.6 cm. Gouache on paper. The attribution at the foot of the painting is in Shāh Jahān's own hand.

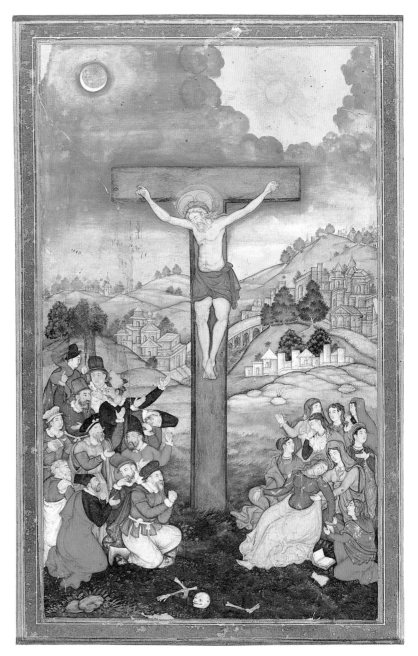

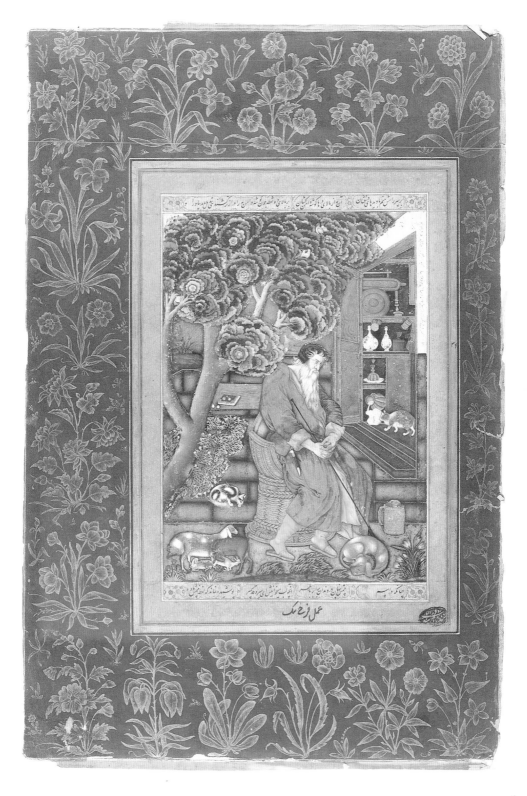

have objected very violently, for Jesus is one of the prophets in the Koran and Mary accordingly greatly revered in Islam. However, in spite of the marked Muslim prejudice against scenes from the Passion or Crucifixion illustrating the godhead of Christ, which the Koran denies, Crucifixion and Deposition scenes were commissioned, like the magnificent page for Akbar probably by the painter Kesū Dās.

Madonnas from Rome do not, however, go very far to explain the very European use of colour, or indeed the adoption of stereoscopic perspective in which the elements of a composition are rigidly subordinated to the conception of a single vanishing point. One of the characteristic features of the fine miniature painting of Turkey and of Persia in the sixteenth century, and of painting in Islam in general, is the absence of this, so that its occurrence in Mughal painting must have been in spite of, rather than because of, the influence of ʿAbd al-Ṣamad and Mīr Sayyid ʿAlī. Instead there may be several vanishing points, or the composition may be organised round the most important figure, who may thus be the largest or the most conspicuously placed. In many fine Islamic paintings, as indeed in the late Gothic manuscript painting of Northern Europe, it is left to the viewer to organise the space as he or she will, the eye roving from exquisite detail to exquisite detail, without the necessity of arranging them in a single unifying visual order.

How and why the painters of Akbar's studio made this radical change remains obscure, but it is doubtful that they would have mastered stereoscopic perspective merely by being shown European compositions in which it was used. Perhaps the Jesuits gave them lessons, or perhaps they learned from the European painters we know to have been at the Mughal court: there is no reason to suppose that the latter were particularly talented, but drawing in perspective was one of their basic accomplishments. However, given the importance of prints after Albrecht Dürer and his circle, it is more probable that Akbar's painters acquired their knowledge of the workings of perspective from Dürer's own experiments in this area, as described in his *Unterweysung der Messung mit dem Zirckel und Richtscheyt* (A course in the art of measurement with compass and ruler), one of the very few practical treatises on linear perspective to circulate in the Renaissance and which went through not only repeated German editions but also a Latin translation by Joachim Camerarius which was known all over Europe.

There was, however, more to perspective than geometry, as the Northern European painters discovered and as they taught the Italian painters of the High Renaissance: colour had to be similarly

organised, either in tonal changes, without blurred contours, as distance recedes to the horizon, or, as Leonardo found, by *sfumato*, gradually making contours indistinct so that they disappear into a mist or haze. Akbar's painters mastered this too, and the landscapes of the *Khamsa* of Niẓāmī made for him in 1595 almost suggest that a series of late Gothic Books of Hours or fine early sixteenth-century Flemish landscapes by Joachim Patinier, Hieronymus Bosch or Herri Met de Bles had been miniaturised, encompassing a whole art gallery in a single volume, as it were. The comparison is not wholly fanciful, for these illustrations abound in details of European paintings decorating interior walls or furniture. However, it will not do. For the late Gothic Books of Hours were too highly prized by contemporary European collectors ever to have been acquired by the missionary orders; and the great Flemish painters were so avidly collected by European monarchs, notably by Philip II of Spain, that it would have been out of the question to offer them as gifts to Akbar or Jahāngīr. (Diplomatic gifts, it should be remembered, are normally selected by considerations of what the donor will miss least.) There are, however, various alternative explanations of how the Mughal painters could have learned the important chromatic trick.

One is perhaps unexpected: Flemish tapestries, the scale of which was conceived for the great halls of freezing northern castles, not for the scorching palaces of the East. Little account was taken either of the taste of markets abroad or of the unsuitability of Muslim palace architecture where wall-space was generally inadequate to hang them properly, but by the later sixteenth century Flemish tapestries were being regularly sent as diplomatic gifts with embassies to the Ottomans, the Safavids and the Mughals too: for example, a set of Arras tapestries depicting the exploits of Alexander the Great was presented in 1607 by a Spanish embassy to Shāh ʿAbbās in Isfahan. This continued. Sir Thomas Roe included Flemish tapestries among the gifts suggested for the Mughal court in 1617–18 and he even seemed to think that they would sell well in India.

The role of tapestries in spreading knowledge of paintings by the great masters even in Europe was fundamental. By the mid-sixteenth century the principal Flemish tapestry-weaving centre was Brussels, executing work after cartoons by practically every school of painting in contemporary Europe. Tapestries after cartoons by earlier sixteenth-century painters like Hieronymus Bosch also remained very much in vogue, even though their paintings were all inaccessible in royal collections. They were therefore an important documentary source for painters outside the

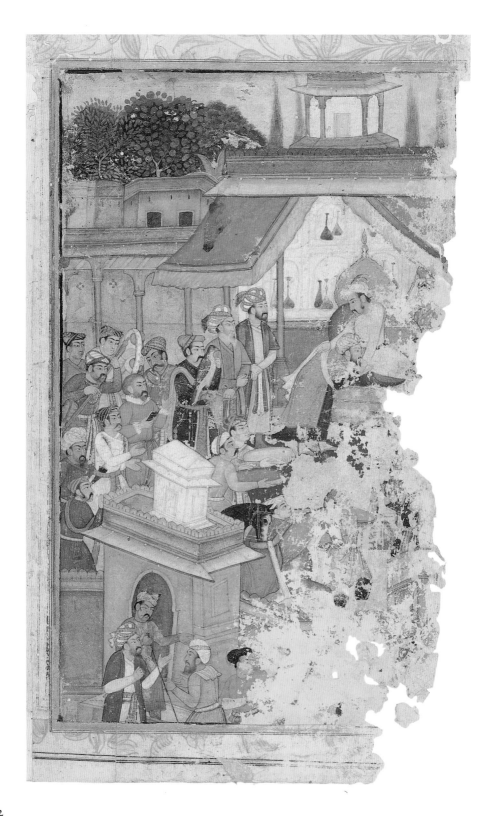

immediate circle of Royal patronage. Few sixteenth-century tapestries survive today, and most original colour schemes have long faded into tones of greyish beige; but from those that do remain we can easily guess that in pristine condition they must have been almost as brilliant as the paintings upon which they are based, and not even an uninstructed viewer would have had the slightest difficulty in appreciating the subtle way in which receding planes were marked by colour gradations. Obviously one set of tapestries would have been enough to show the Mughal painters how this was done, and the trick would then have been transmitted from the painters to their apprentices without the need for the latter to refer back to the tapestries. The parallel between paintings and tapestries is even more seductive in that the paintings of the 1595 *Khamsa* are so clearly vastly reduced versions of much larger compositions. The Mughal painters would have found no difficulty in adapting tapestry compositions in this way.

In late sixteenth-century Northern Europe it was not only the Flemish tapestries which reproduced paintings and styles of an earlier generation: contemporary Northern landscapes on panel also continued to be painted in a markedly old-fashioned style and, being much cheaper and more numerous, could well have reached India, though their greater fragility would scarcely have allowed them to survive a steamy monsoon climate for long. Such gifts to the Mughals could, therefore, also have brought their studio in contact with the perspective and colourism of earlier Flemish painting, and the small dimensions and often miniature technique of this school would have lent themselves to more or less direct copying, so that there is a decided possibility that further work on Mughal painting will allow us to identify the European painters whose works were actually used. We do not have to choose between tapestries and landscape paintings on panel as the sources, however: both could well have been employed; and in the seventeenth century, Dutch landscapes, to judge from a woodland scene after Isaac Gillis van Coninxloo or Jacob Savery, were also available. By any criterion, the painters' ability to master and adapt their conventions is a remarkable achievement.

46 OPPOSITE Reception of foreign ambassadors. *c.*1620. Album leaf. 23.3 × 14.3 cm. Gouache on paper. The figure in European costume has been conjecturally identified as Sir Thomas Roe, the ambassador of James I of England to the Mughal court.

— 5 —

AKBAR'S STUDIO

47 OPPOSITE The struggle of Rustam with the White Dīv of Mazandaran, an episode from the *Shāhnāme* of Firdawsī, the Persian national epic, worked up as an album leaf. *c*.1630. 15.4 × 23.4 cm. Line and wash on paper.

The steady increase in the volume of manuscript production in the last two decades of Akbar's reign demanded not only an enormous staff but also simultaneous production in several centres. Even in Persia under the Safavid Shāh Ṭahmāsp it was not unknown for texts to be copied in various places at once, the pages then being collected together and distributed to the illuminators or the illustrators, and only becoming a manuscript when finally they were bound. Since Akbar spent so much of his reign on the move, moreover, many of his favourite painters must have been in his suite. We know from colophons that in addition to Agra, Fatehpur Sikri, Lahore, and, under his rebellious son Shāh Salīm (Jahāngīr), Allahabad, all at one time or another housed scriptoria. This veritable mass-production of fine painting was further augmented by manuscripts ordered for or by Akbar's court officials as gifts or to spread knowledge of the texts through the empire.

It was with Akbar's accession in 1556 that Humāyūn's foresight in recruiting painters experienced in running and administering a large studio-scriptorium bore fruit. For his means enabled him to employ artists on a scale hitherto unparalleled anywhere else in Islam, or even in Europe. Judging by scribal notes in manuscripts made for Akbar later in his reign, their calligraphy was slow – sometimes no more than sixteen or seventeen lines a day – and some

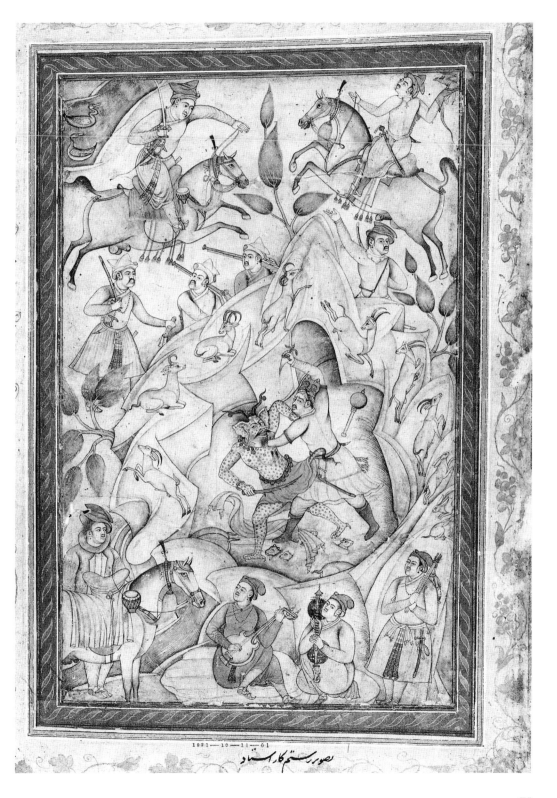

تصویر رستم کار استاد

of the most highly finished miniatures could have taken as long as two months each. The punctual completion of the much larger and not markedly less complex illustrations to the *Ḥamza-nāme*, at least 1,400 in number – even if, as we are told, they were executed over fifteen years (1562–77 or 1567–82) – would therefore have entailed a permanent staff of at least a hundred active painters, even if not all of them were the 'acknowledged masters' in Akbar's studio mentioned by Abu'l-Faẓl in the 1590s. The enterprise must have taken up all their time and it is scarcely surprising that the next fine illustrated manuscript made for Akbar, the *Anvār-i Suhaylī*, had to wait till 1570, no less that fifteen years after his accession. Thereafter the production of grand illustrated manuscripts like the copies he ordered of the *Bābur-nāme* and the *Akbar-nāme* (many of them with double-page illustrations and with as many as a hundred and fifty fine paintings in all), at the rate of five or more a decade, must often have been in danger of overstretching the capacities of the studio.

Patronage under both Akbar and Jahāngīr must principally have involved financing an enormous and hyperactive studio and ordering the texts to be copied and illustrated. The extent of their interference should not, therefore, be exaggerated. But their painters had to take account of the directions in which their taste evolved. Akbar's personal preference for an Indianised Safavid style is, for example, borne out by the fifteen master-painters listed by Abu'l-Faẓl in the 1590s, all but two of whom were Hindu.

Difficult as it is to give adequate artistic biographies of any of Akbar's painters, the fact that from the early 1580s onwards paintings regularly bear attributions to one or more of them is a clear indication that they were for Akbar's information and not merely for the purposes of keeping accounts. There was a strong hereditary element in the studio, though sometimes a painter's son might better himself. ʿAbd al-Ṣamad's son, Muḥammad Sharīf, for example, even if he was originally trained in his father's craft, became an officer and boon-companion of Jahāngīr's, so was unlikely to have had much time for painting. There is too little space here to relate the biographies of all the painters known to have worked for Akbar, but some are instructive. The hereditary element is exemplified by Basāwan, who may have been active up to *c*.1600, one of Akbar's finest painters and the father of Manōhar, two of whose paintings in the *Khamsa* of 1595 show him to have been a master of landscape composition. Under Jahāngīr, Manōhar was, however, turned to portrait-painting, which he may have found less congenial; but he had a long career and ended his days in the service of Shāh Jahān's son Dārā Shikōh. And Abu'l-Ḥasan,

whom Jahāngīr so admired that he gave him the title *Nādir al-Zamān* ('the Rarity of his Time'), was the son of an Isfahan-trained painter, Āqā Riżā of Herat, who had entered Akbar's service in 1584.

As has already been noted, the corporate nature of work in the Imperial Mughal studio often makes it difficult to determine which of the painters who worked on a particular composition did what, and it is correspondingly difficult to discover exactly why the Mughal emperors admired them. Basāwan's name first appears in the *Ṭūṭīnāme* completed for Akbar in the early 1560s, but it most frequently occurs in the great manuscript projects of the 1580s and 1590s. Rather surprisingly, however, his participation was not invariably a guarantee of a top-class manuscript: the *Dārāb-nāme*, to which he contributed a magical roofscape, inexplicably contains a number of markedly poor illustrations – doubtless by painters who were sacked as a result. One of his finest compositions shows Akbar subduing the mad elephant Hawā'ī, full of dramatic colour contrasts and vivid detail, including a boatman desperately trying to keep his boat afloat.

Abu'l-Ḥasan reveals his Persian ancestry in illustrations which are markedly Safavid in style, but, as Jahāngīr himself observed, his talent was far superior to the smooth and somewhat vapid competence of his father, Āqā Riżā. In 1009/1600–1, at the age of only thirteen, he executed a drawing of St John based on the figure of the disciple in Dürer's 1511 engraving of the Crucifixion. Here his talent for plasticity and modelling shows itself as already well developed. Although his signed or attributed work covers practically the whole range of Jahāngīr's interests, he came increasingly to be employed in portraiture, particularly of an allegorical sort, representing Jahāngīr's dreams of world mastery, or the preference he claimed for the society of shaykhs and Sufis to the cares of kingship. The allegories in Abu'l-Ḥasan's portraits are much more European than Islamic and those selected must have been Jahāngīr's own idea. Richard Ettinghausen and Robert Skelton have both remarked, for example, on the use of imagery from the *Fourth Eclogue* of Virgil in his prediction of a coming Golden Age, where the ox, the lion, the goat and the serpent all live in peace with one another. But even more striking evidence of Abu'l-Ḥasan's closeness to Jahāngīr is a portrait in the Rampur State Library generally agreed to be of his famous wife, Nūr Jahān, whom he married in 1611 and who in the later years of his reign more or less took government into her own hands. She was an excellent shot and accompanied Jahāngīr on many of his hunting expeditions, so can scarcely be said to have lived the sheltered life of the harem. Here,

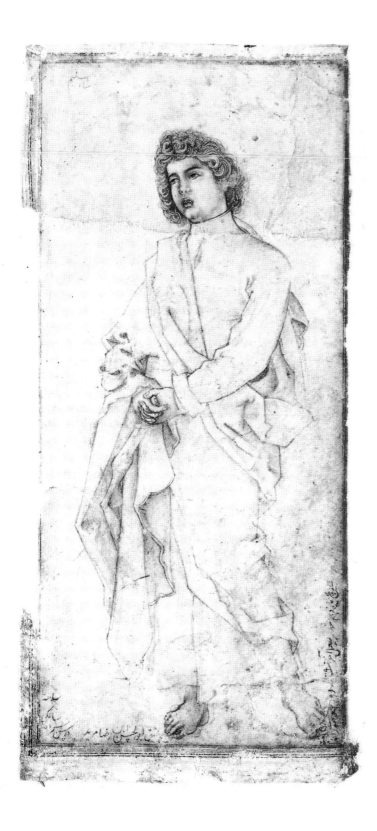

49 St John, after the
engraving of the
Crucifixion in the small
Passion engraved by
Albrecht Dürer in 1511.
By Abu'l-Ḥasan at the
age of thirteen.
Executed for Jahāngīr,
probably at Allahabad,
and dated 1009/1600–1.
10.1 × 4.5 cm. Ink on
paper.

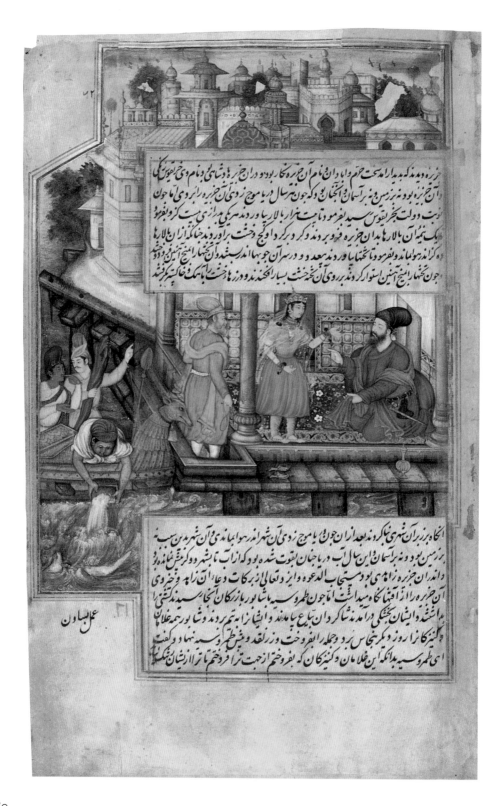

however, she is shown in male attire, head thrown back, loading an enormous musket, a daring treatment of a highly unconventional theme in Islamic painting.

At Akbar's death in 1605 his library was estimated at 24,000 volumes with a total value of 6,500,000 rupees. If the number seems incredible, he did have exceptional opportunities. In 1595, for instance, he inherited 4,600 bound volumes from the library of his deceased court poet, Fā'iẓī, the brother of Abu'l-Faẓl, some of them almost certainly illustrated. They were catalogued in three groups: verse, medicine, astrology and music; philosophy, mysticism, astronomy and geometry; and Koranic exegesis, Muslim tradition and Islamic law. The valuation of Akbar's library will not, of course, allow the estimation of an average value per volume, since many volumes – verse anthologies or theology, for example – would not have been illustrated or even illuminated and may have been the work of apprentice copyists, not trained calligraphers; while the grandest works, like the illustrated presentation copies of the *Akbar-nāme* and the *Bābur-nāme* made for Akbar, would even then have been beyond price.

We have, unfortunately, no comparable estimates for either the size or the value of other great libraries of the time, like that of Shāh ʿAbbās I at Isfahan or the library of the Ottoman Sultan, Murād III, in Istanbul. But the estimate compares interestingly with other major projects of Akbar's and Jahāngīr's. By 1580, it has been calculated, Akbar's annual revenues were probably in the region of 15,000,000 rupees, of which he may have spent about half; in any case, when he died he left a full treasury. His mausoleum at Sikandra outside Agra, built after his death by Jahāngīr, cost about 1,500,000 rupees, and Jahāngīr's expenditure on the Red Fort and other palace buildings at Agra, doubtless over several years, however, may have amounted to as much as 3,500,000 rupees. Akbar's own expenditure on Fatehpur Sikri was only about 2,000,000 rupees and that over sixteen years with perhaps no more than 250,000 rupees at peak periods of building activity. Though the comparison may exaggerate somewhat, it is difficult to think of another enterprise in the whole history of artistic patronage when a library cost three times as much as a city.

50 OPPOSITE Tamarūsia and Shāpūr reach the island of Nigār ruled by Khārikūs. By Basāwan, *c.*1585. 29 × 19 cm (illustration); 35.3 × 23 cm (page). Gouache on paper. From the *Dārāb-nāme* (the exploits of Dārāb, the son of Zāl and the grandfather of Alexander in the Iranian tradition), by Abū Ṭāhir b. Ḥasan b. ʿAlī b. Mūsā al-Tarasūsī.

— 6 —

THE IMPERIAL
STUDIO UNDER
JAHĀNGĪR

The prime importance of official portraiture under Jahāngīr as well as under Akbar is demonstrated by the pavilion Jahāngīr redecorated in 1620 in the Nūr Afzā gardens on Lake Dal in Kashmir where the place of honour was held by portraits of Humāyūn and Akbar, opposite those of himself and his 'brother', the Safavid Shāh ʿAbbās I. Then came princes of the blood, including his real brother, Sultān Dāniyāl, who had died young, sodden with drink and drugs, in 1602, and a series of portraits of his ministers. Jahāngīr had previously sent a court portraitist, Bishn Dās, to Isfahan with a diplomatic mission to take Shāh ʿAbbās's likeness. The puny figure he depicted, so different from Safavid portraits of the Shāh, may or may not have been true to life, but it came in very useful when the suspicion which tinged Jahāngīr's 'fraternal' feelings for Shāh ʿAbbās was justified by the latter's occupation of Kandahar in 1622. His pictorial revenge was a series of official paintings mounted in the Imperial albums, now divided between Washington and Dublin, showing the two rulers above the world but with Shāh ʿAbbās (as cut down to size by Bishn Dās) reduced almost to a suppliant.

In Jahāngīr's palaces and audience halls European religious pictures were also prominent, even when their subjects were mysterious or emblematic. As we learn from a letter of Sir Thomas Roe, James I's ambassador to Jahāngīr, to the East India Company

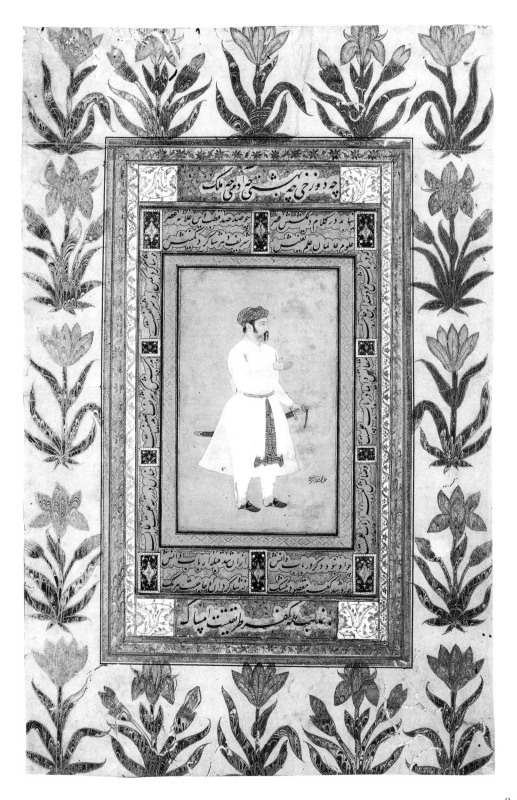

in London in 1615, describing the opportunities for trade: 'Here are nothing esteemed but of the best sorts: good Cloth and fine rich Pictures, they comming out of Italy overland from Ormuz… and doubtless they understand them as well as wee; and what they want in knowledge they are enformed by the Jesuites and others.' There is other evidence that Jahāngīr took care to know what his pictures were about. Earlier that year Roe had also stipulated that the pictures should be large, of fine quality and on canvas; and in addition should be narrative and have many faces. That was obviously a pressing consideration. In 1619 Jahāngīr records that he was presented with a painting of Tamerlane's defeat in 1395 of Tokhtamysh Khan, the ruler of the Golden Horde, which had apparently been scandalously stolen from Shāh ʿAbbās's library by his librarian, Ṣādiqī Beg. It was naturally precious to him as a memento of Tamerlane, and it also bore the signature of a painter, Khalīl Mīrzā Shāhrukhī, of whose work we know nothing but who from his name was in the service of Tamerlane's son, Shāh Rukh. In Jahāngīr's view, he could have been the teacher of the renowned Persian painter, Bihzād. What Jahāngīr most valued about it, however, was that it had no fewer than 240 figures in it.

The painting does not survive to bear out Jahāngīr's assertion, yet it shows that he was not merely an avid collector but a connoisseur with strong views. He writes elsewhere in his memoirs:

My liking for painting and my practice in judging it have arrived at such a point that when any work is brought before me, either of deceased artists or of those of the present day, without their names being told me I say on the spur of the moment that it is the work of such and such a man, and if there be a picture containing many portraits, and each face be the work of a different master, I can discover which face is the work of each of them. And if any other person has put in the eye and eyebrow of a face, I can perceive whose work the original face is and who has painted the eye and eyebrows.

These claims are somewhat difficult to square with Jahāngīr's pride in his painters' ability to produce identical copies of works in his collection. Sir Thomas Roe presented him with a female portrait on vellum by the English miniaturist Isaac Oliver (1551–1617). This Jahāngīr had one of his 'workmen' (perhaps even Abu'l-Ḥasan or Manṣūr) copy and challenged Roe to distinguish the copies from the original. They were mounted and shown to him by candlelight, but, despite the poor light, Roe readily, he reports, discerned the original and explained to Jahāngīr the grounds for his conclusion –

52 OPPOSITE Female lutenist in a European chair. Album leaf. Late sixteenth century. 17.2 × 11.8 cm (within margins). Gouache on paper.

53 Woodland scene. Album leaf, after an engraving by the Flemish painter Isaac Gillis van Coninxloo (1544–1607) or the Dutch painter Jacob Savery (d. 1602). Period of Jahāngīr (1605–27). 26 × 17.5 cm. Gouache on paper.

54 OPPOSITE LEFT The funeral of Alexander the Great. Album leaf. c.1600. 10 × 7.4 cm. Gouache on paper. Inscribed in the centre ʿamal-i Salīm-quli and evidently the work of one of Jahāngīr's painters when, as Shāh Salīm, he had seceded to Allahabad. The bier is covered with an Ottoman silk textile.

an amusing exercise in boastful connoisseurship, though he somewhat reluctantly concedes that in the art of limning (portrait miniatures) Jahāngīr's painters 'work miracles'. Not, however, that Jahāngīr would necessarily have been taken in either: his numerous attributions in his own hand of paintings executed by the painters of his studio may be taken with considerable confidence.

Jahāngīr was far from averse to receiving manuscripts as presents, and they must have been many and rich, like the illustrated copy of the romance of *Yūsuf and Zulaykhā* ('Joseph

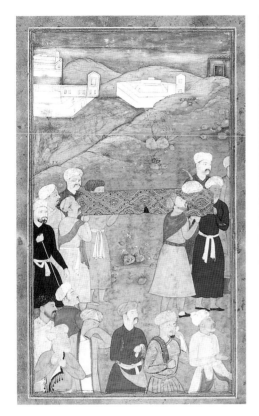

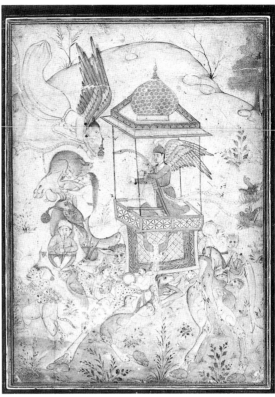

and Potiphar's Wife') presented by ʿAbd al-Raḥīm Khān-i Khānān which, Jahāngīr notes, was worth 1,000 gold mohurs. His influence on the production of books is, however, mostly evident in tinkering with earlier manuscripts, both Mughal and from Persia and Transoxania, ordering miniatures to complete unfinished works or painting himself or Akbar or his sons into them.

His actual manuscript commissions were few. They include a copy of the *Jog-Bashisht*, dated 1602, made for him at Allahabad where, a few years before his accession, he had rebelliously established his own court. This *Jog-Bashisht* (Dublin, Chester Beatty Library, MS Ind. 5) shows a new tonality of colder, more transparent colours (cf. an album leaf depicting the funeral procession of Alexander the Great which was probably executed at Allahabad at this time) as well as simplified compositions and an increasing use of wash and line drawing (*nīm-qalam*), but the evolution may show changes as much in Akbar's as in Jahāngīr's personal taste. For Akbar on his return to Lahore in 1598 took with him the Isfahan-trained Āqā Riżā Haravī, a specialist in *nīm-qalam*, and also his son, Abu'l-Ḥasan, who was to become one of Jahāngīr's favourite painters. Though Āqā Riżā had been in

55 ABOVE RIGHT Peri harpist riding a composite camel. Album leaf. Seventeenth century. 21.3 × 15.3 cm (with margins). Gouache and gold on paper. In the eastern Islamic versions of the Alexander Romance his horse, Bucephalus, is often shown as a composite creature.

56 Phoenix (*sīmurgh*) attacking a *rukh*, the mythical enemy of the elephant. Album leaf. Seventeenth century. 13.5 × 21.2 cm. Gouache on paper.

Akbar's service since 1584, his first dated work is vignettes in the margins of Jahāngīr's Gulshan album in the Gulistan palace in Teheran, the earliest pages of which were probably commissioned *c*.1599. Very probably, therefore, the vignettes in which they abound, so richly as almost to distract attention from the paintings they frame, were a taste which Jahāngīr had already acquired at Allahabad.

The portraits and religious paintings hung in public were well reflected in the contents of the great albums made for Jahāngīr: two of them, one in Berlin and one in the Gulistan palace in Teheran, that remain largely intact suggest that his exceptionally varied tastes were also formed even before he reached the throne. They include calligraphy, particularly the work of Sulṭān ʿAlī Mashhadī and Mīr ʿAlī Haravī whose work had given them legendary fame in Persia; early Mughal painting of the period of Humāyūn, including works by ʿAbd al-Ṣamad; European prints and drawings of religious or allegorical subjects together with Mughal copies or versions of them; a few Deccani paintings; and a range of contemporary portraits, of Jahāngīr and of his officials. The scope and thematic content of the albums had already been established in albums compiled for the Timurid, Turcoman and Safavid rulers of

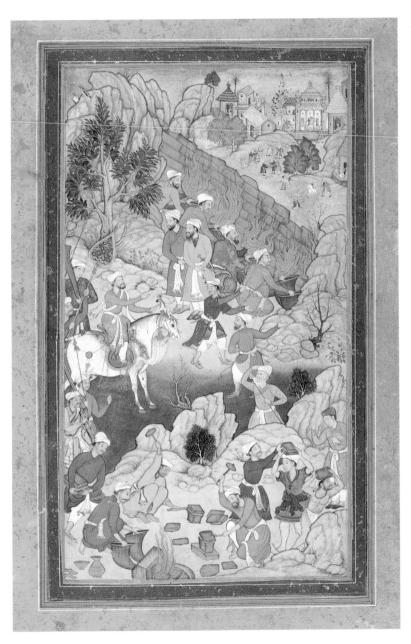

57 Alexander the Great building a brazen wall across the Caucasus against the peoples of Gog and Magog. Album leaf, after an illustration to the *Iskandarnāme*, one of the five books of Niẓāmī's *Khamsa*. *c*.1600. 29.5 × 16.9 cm (page); 41.1 × 26.8 cm. Gouache and gold on paper.

Persia, but the choice of material obviously reflects Jahāngīr's own taste. Later albums and those made for his successors (like the Kevorkian album compiled for Shāh Jahān, now in the Metropolitan Museum, New York) take care to follow that, with the result that much of their contents are copies of works in Akbari or Jahangiri style: here, the date when they were actually made was plainly less important than the date of the original.

For many of these categories we have evidence in Jahāngīr's own words. His interest in Sufis, for example, which went well beyond that of contemporary Muslim rulers, also appears in Imperial albums in genre paintings of rulers or princes visiting ascetics. And although other Mughal sources confirm European reports that the Jesuits maintained their favoured status at his court, his own memoirs suggest greater sympathy for Hinduism: hence, doubtless, the Allahabad *Jog-Bashisht* and also genre paintings of saddhus and yogis. Interestingly, however, the many European religious paintings hung in the royal palaces and the paintings on Christian themes, after Flemish or North German engavings, executed in the Mughal studio evoke no literary response in his memoirs; they cannot therefore be taken as conclusive evidence of his inclination (which Western missionaries were naturally prone to exaggerate) towards Christianity.

From the very beginning of his reign Akbar's commissions had included illustrated manuscripts of works of literature and romance such as were made for the great libraries of the Timurids and the Safavids. By the latter part of his reign, on the other hand, and even more so under Jahāngīr and Shāh Jahān, Mughal painting had become in the widest sense largely biographical – illustrations to chronicles, portraits and natural history, as well as biography proper. The memoir of Humāyūn by his daughter Gulbadam appears never to have been illustrated, but the Mughals' continuing admiration, even reverence, for the *Bābur-nāme*, first shown by the series of magnificent copies executed for Akbar and his court from *c*.1589 onwards, is strikingly illustrated by Jahāngīr, in whom Bābur found an assiduous disciple: not only did he partially transcribe part of Bābur's Chaghatay text, which filled in some important gaps where it may have been abbreviated in the course of its translation into Persian; he also wrote his own autobiography, the *Tūzuk-i Jahāngīrī* (literally, the *Regulations of Jahāngīrī*), covering the first eighteen years of his reign (1605–27). In March 1619 he ordered the events of the first twelve years of his reign, that is, volume I of the *Tūzuk*, to be bound up in various presentation copies, the first being for the future Shāh Jahān. It is thought that the illustrations to them were not in the text but were bound in separate albums, though the frontispiece, by Abu'l-Ḥasan, *Nādir al-Zamān*, showing Jahāngīr's accession, was evidently for the Shāh Jahān presentation volume.

The proprietorial nature of these illustrations is well conveyed by the page in the British Museum showing Jahāngīr's son Khurram 5 (Shāh Jahān) being weighed in gold and silver, a Mughal ceremony associated with the beginning of the solar year. The hand of

Manōhar can be seen in the rich garden-landscape background. It is, of course, first and foremost a portrait of Jahāngīr and his son with his generals and his ministers around him. Jahāngīr is shown with his ears pierced, a sign of his allegiance to the Chishtiyya order of dervishes, which he had vowed to have done on his recovery from a serious illness in 1614. But it is also a celebration of his treasures. In the foreground are the rich presents offered for the occasion, some of them in wrappers of cloth of gold or brocaded or embroidered silks, all laid out on a fine carpet. And in the background under the awning are balconies draped with more carpets and alcoves displaying some of his collection, vessels of coloured glass, agate, rock-crystal or jade, Chinese porcelains and figurines which, it has been suggested, may have been early specimens of imported Ming blanc-de-Chine. It is not merely the detail of the painting which is magnificent: magnificence is its subject.

Autobiography in classical Islam, as in mediaeval Europe, was little practised and Bābur's memoirs are not only one of the greatest but also one of the first exercises in the genre. The *Tūzuk* is far more a work of conscious artifice than the *Bābur-nāme* and, judged even by the canons of the time, Jahāngīr lacked the literary training not to obtrude his personality. The memoirs are certainly frank, sometimes even rebarbatively so, and record, for example, aspects of his private life, notably indulgence in opium or drink, which were offensive to orthodox piety and could therefore scarcely be illustrated. But (at least till they become swamped with the self-pity of Jahāngīr's middle age) they share a great attraction with the *Bābur-nāme*: their high spirits, as in the hyperbole of his commination of Ahmadabad in Gujarat, which may well be a conscious imitation of Bābur's own diatribe against India, where he fell seriously ill in the spring of 1618:

Its air is poisonous and its soil sand and dust. Its water is undrinkable and the river, which flows by the side of the city, dry except in the rains. Its wells are mostly salt and the cisterns of the city have become like buttermilk from washermen's soap ... I do not know whether to call it 'Samūmistan' [the haunt of the dust-devil] or 'Bīmāristān' [Bedlam] or 'Zaqqūmzār' [bed of hellish thorns] or 'Jahannamābād' [the abode of Hell].

Jahāngīr's affection for his pets – including cheetahs, carrier pigeons and a pair of cranes he called Laylā and Majnūn after two ill-fated lovers of Persian romance – might, however, be taken to bear out a suspicion that love of animals often goes with inhumanity. His consideration for the elephants of the royal stud was

58 NEXT PAGE Prince Khurram weighed in gold and silver. From an album of illustrations, now dispersed, to the *Tūzuk-i Jahāngīrī* (Memoirs of Jahāngīr), c.1615. 26.6 × 20.5 cm. Gouache on paper.

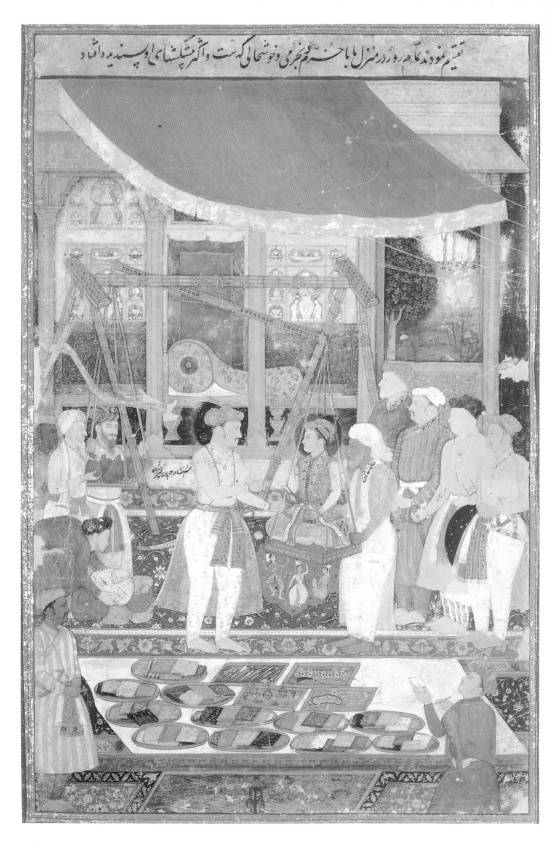

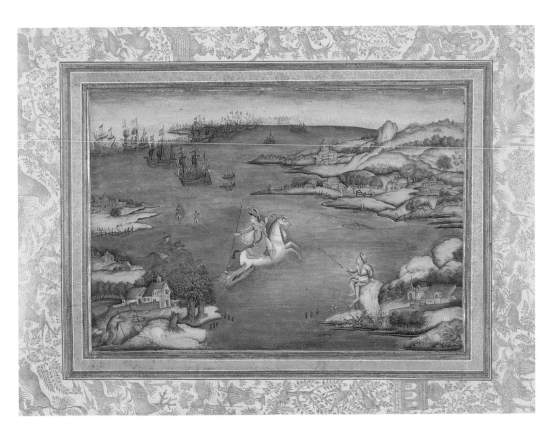

famous. He very rarely gave them away and then only as a mark of special favour (for example, to the painter Bishn Dās: the absence of any other emoluments suggests that it was white!). He describes in pathetic detail the death of an elephant from rabies. And, with a consideration remarkable for its time, observing that in winter the elephants shivered as they bathed, he ordered them baths in warm water. With human beings, however, Jahāngīr's curiosity could be downright cruel. When a former court favourite, ʿInāyat Khān, then in the last stages of illness, came to him to solicit aid, Jahāngīr detachedly observed, 'though painters have striven in depicting an emaciated face, yet I have never seen anything like this . . . As it was a very extraordinary case I directed painters to take his portrait.' Two versions of the result, both probably by Govardhān, in the Museum of Fine Arts in Boston and in the Bodleian Library, depicting the dying ʿInāyat Khān in the litter in which he was carried to court, are as cold as Jahāngīr's comfort.

As such anecdotes show, Jahāngīr was a visual glutton. His passion for nature was unrestrained. Like Bābur before him he was never too occupied to build a garden and his descriptions of landscapes show a powerful graphic imagination. When in Kash-

59 Equestrian deity, perhaps Bellona, spearing a Ganges crocodile in a Flemish landscape. By Mīr Kalān Khān, early seventeenth century. Album leaf with lavishly illuminated eighteenth century margins. From the Polier album. 18.14 × 26.1 cm. Gouache and gold inks on paper.

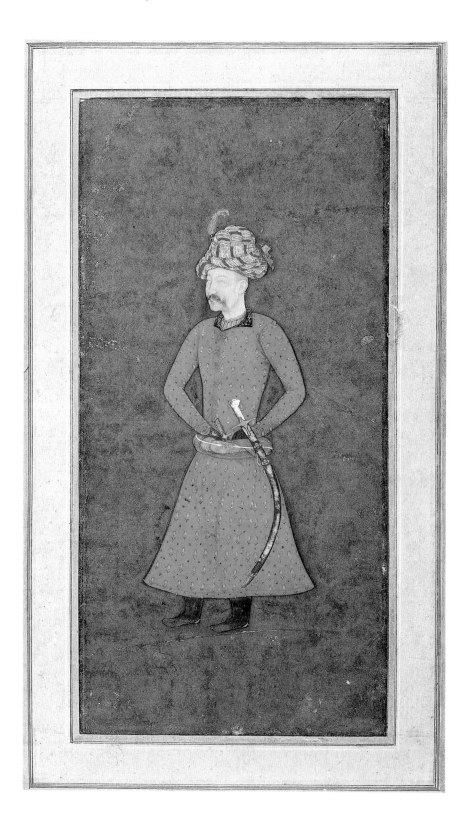

mir prior to his accession in 1605, he visited the fountain of Virnag above Pampur and built a garden round it with a great octagonal fishpond linked by a channel to the gateway at the entrance and surrounded by domed arcades and flowerbeds. The clear water, he says, showed the brilliant green of the hill behind, and among the flowers he planted there one had a stem variegated like a peacock's tail which swayed and was reflected in the ripples of the channel, a graphic description almost prefiguring the intoxicated fantasies of Coleridge's Xanadu. Many other passages in the *Tūzuk* are clearly conscious of their suitability for illustration, like his observation of the kids of some Barbary goats he had bred: 'Some of their ways are such that the mind derives uncontrolled pleasure from looking at their frolics; it is well known that painters cannot draw properly the motions of a kid.'

As for rarer or more exotic flora and fauna, Jahāngīr says, curiously overlooking the paintings of Indian flora and fauna in the copies of the *Bābur-nāme* made for Akbar:

Although Bābur in his memoirs has described the appearance and shape of several animals, he had never ordered painters to make pictures of them [poor Bābur for most of his career can scarcely have had a painter to his name]. As these animals appeared to me to be very strange I both described them and ordered that painters should draw them in the *Jahāngīr-nāme* [that is, the *Tūzuk*], so that the amazement which arose from hearing of them might be increased.

60 OPPOSITE Shāh ʿAbbās I of Persia (reigned 1587–1629). Attributed to Bishn Dās, who was at Isfahan in 1613–9, and datable accordingly. 18.1 × 3.9 cm. Gouache on paper.

61 Zebra, with an attribution to Manṣūr in Jahāngīr's own hand dated 1621. From the Minto album. 26.5 × 16.3 cm. Gouache on paper.

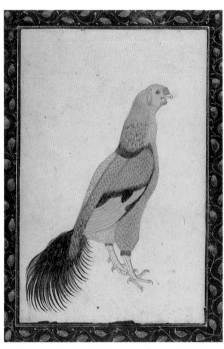

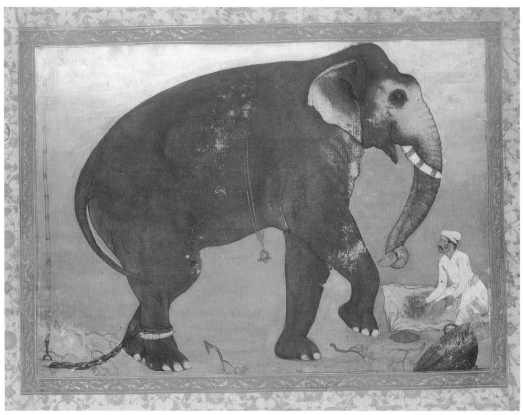

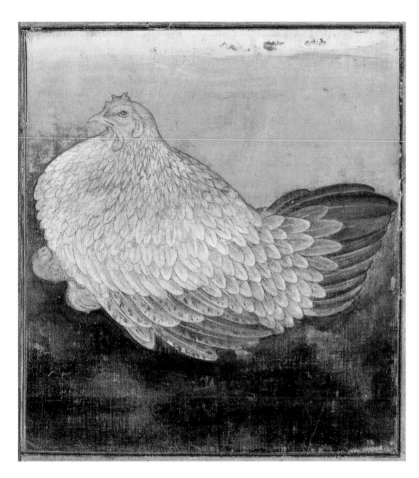

62 OPPOSITE TOP LEFT
Centaurea. Period of
Jahāngīr (1605–27).
16 × 8.3 cm. Gouache
on paper.

63 OPPOSITE TOP RIGHT
Game cock, perhaps
after a signed original
by Manṣūr. Album leaf.
Period of Jahāngīr or
Shāh Jahān, c.1610–60.
16.2 × 10.7 cm.
Gouache on paper.

64 OPPOSITE BELOW
Elephant being fed by
its keeper. Album leaf.
c.1620. 20.7 × 28.9 cm.
Gouache on paper.

65 THIS PAGE Hen and
chicks. The painting
bears an attribution to
Manṣūr, *Nādir al-ᶜAṣr*.
Period of Jahāngīr
(1605–27). 19 × 17.2
cm. Gouache on cotton
gauze.

In this fashion he records their work, at various times, on a
peregrine falcon sent to him as a gift which had died on the way; a
dipper; a roseate starling; a crown imperial (*Fritillaria imperialis*)
'with a tuft of leaves like a pineapple' – he had already planted
pineapples brought by the Portuguese from the New World at Agra;
a turkey-cock brought for him from Goa in 1612, painted by
Manṣūr; a strange sort of tailless monkey; and pheasants he bred in
captivity. Jahāngīr's remarkable description of a zebra brought
from Abyssinia in 1030/1621 is particularly striking:

From nose to tail and from the tip of its ear to the top of its hoof,
black markings, large or small suitable to their position, were to
be seen on it. Round the eyes there was an exceedingly fine black
line. One might say the painter of Fate, with a strange brush, had
left it on the page of the world. Some imagined that its coat had
been dyed. But after minute enquiry it became clear that God was
the creator thereof.

66 OPPOSITE Night scene in an encampment. Early seventeenth century. Signed Bārs (?), with a later attribution to Muḥammad ʿĀrif. 18 × 13.8 cm. Gouache on paper.

Happily, we can place this account side by side with Manṣūr's painting of the zebra, which bears an attribution in Jahāngīr's own hand.

It is hardly surprising that Manṣūr, the painter to whom Jahāngīr refers most frequently and to whom he gave the title Nādir al-ʿAṣr ('the Rarity of the Age'), was renowned for his paintings of birds, flowers and animals. His judgement cannot be faulted: this is natural history painting at its finest. Manṣūr has no biographer and his career is otherwise known from his work, either signed or authenticated by Jahāngīr or by Shāh Jahān. By the time of the Bābur-nāme of c.1590 (British Library, Or. 3714) he was sufficiently established for various studies of birds and three figural scenes to be attributed to him by the supervising librarian as his sole work. His name also appears on fine illumination of the 1590s – though not, apparently, on the historical margins of the great albums made for Jahāngīr which were most probably begun c.1599 – and the minute treatment of his subjects may owe much to this early specialisation. Although he was not particularly renowned for his portraits, Manṣūr's study of the vina player ʿAlī Khān Karūrī of c.1600 shows the same exquisite eye for detail. His fame survived his death and later copies of his works, some recognisable as such, continued to be made until the nineteenth century. There are also, however, contemporary copies, both unsigned duplicates by Manṣūr himself as well as others by other artists, sometimes copying his signature, sometimes not. Not all unsigned Jahangiri studies from nature, therefore, can be attributed to Manṣūr.

The constant experimenting in styles and forms which reflects the passionate curiosity of Akbar and Jahāngīr as collectors has sometimes been worrying for the viewer who comes fresh to Mughal painting, for much of it is markedly eclectic, in both style and subject matter, and eclecticism has not had a good press. Meyer Schapiro seems to speak for many in his observation: 'Nothing in our culture has seemed to its critics so evident a sign of decadence as the taste of artists for works of different times and places and the miscellaneous collecting of objects of different styles.' Far from suggesting the deliberate choice of the best elements of a group of styles and thereby proclaiming the freedom of the artist to create his own style, eclecticism has seemed to betray a cultural poverty, whether of craftsmanship or originality; it thus seems the lazy artist's, or connoisseur's, way out. This prejudice is clearly expressed in Oscar Wilde's Ruskinian stage direction (a joke at Ruskin's expense) in An Ideal Husband on the first appearance of the villainess, Mrs Chevely: 'In short, a work of art, more or less, but showing the influence of rather too many schools.' The joke is

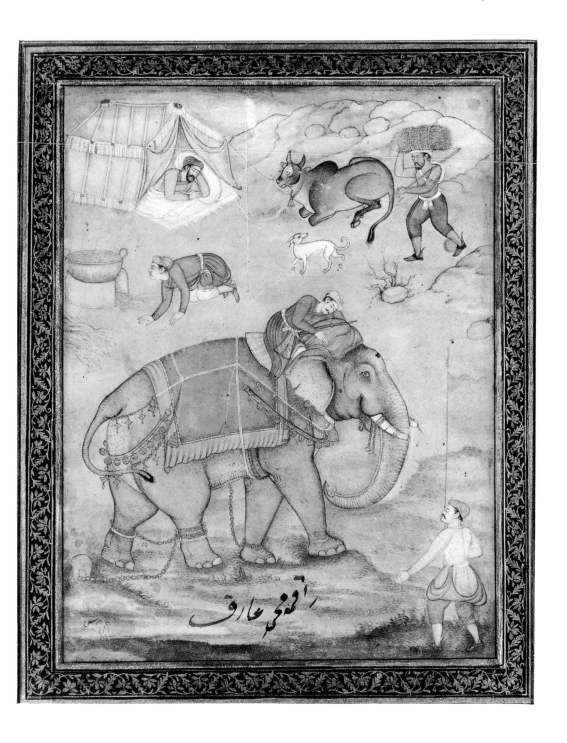

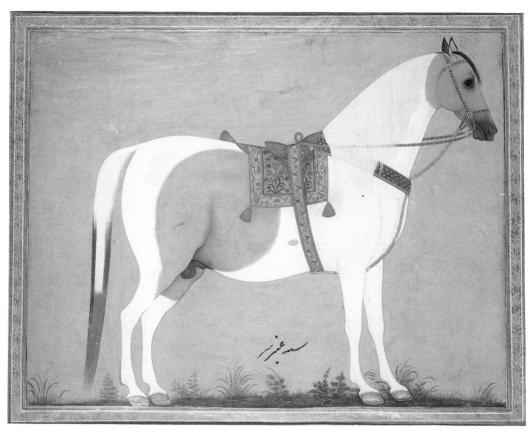

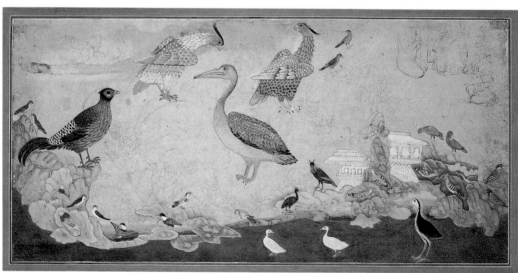

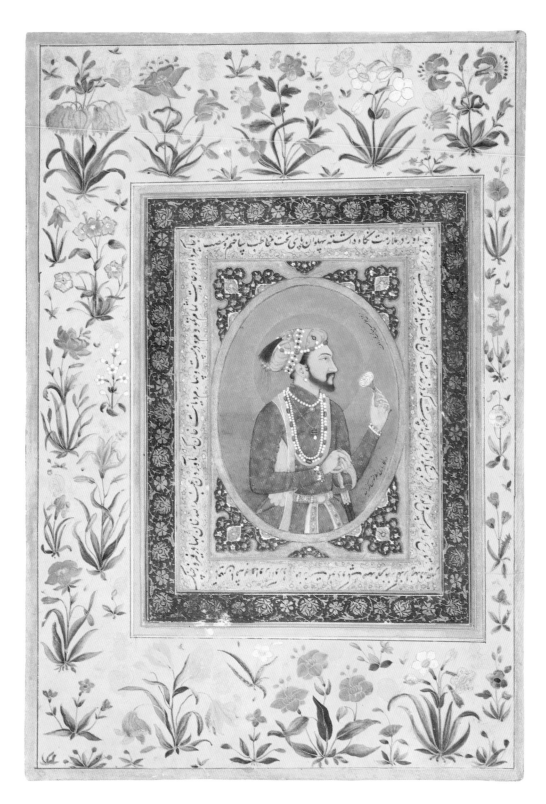

67 PAGE 100 TOP
The horse, 'Amber
Head'. *c.*1650.
31.7 × 23.5 cm.
Gouache on paper.

68 PAGE 100 BELOW
Birds by a pond.
Seventeenth or
eighteenth century.
26.3 × 44.3 cm.
Gouache on paper.

69 PAGE 101 Portrait
of Shāh Jahān at the
age of thirty-six
holding a seal
engraved with his
titles and the regnal
year 1 (1628).
19 × 14 cm. Gouache
on paper. The
gorgeous floral
borders are typical
of the Imperial
albums ordered by
Shāh Jahān.

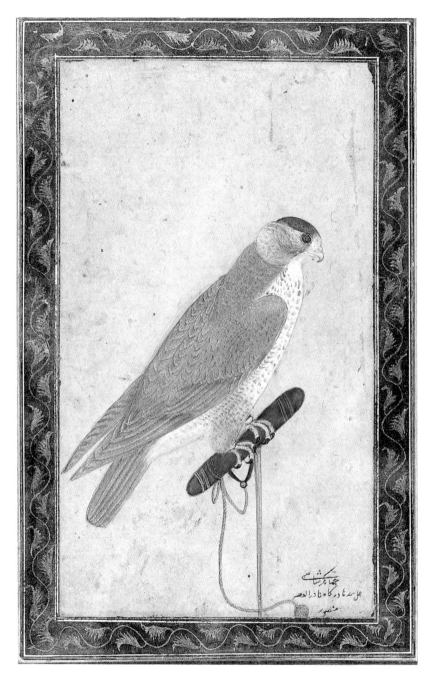

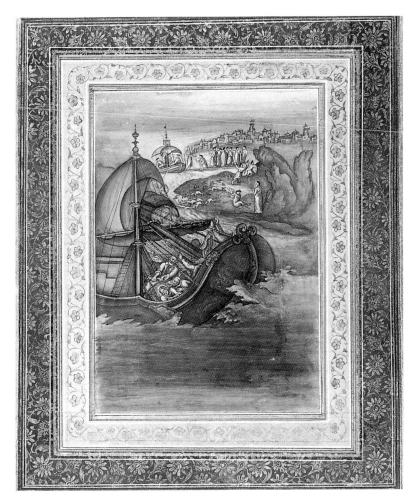

70 OPPOSITE A falcon on its perch. Album leaf. Signed Manṣūr. Period of Jahāngīr (1605–27). 15.2 × 88 cm (inside margins). Gouache on paper. The falcon is evidently that described in Jahāngīr's Memoirs, year 14 (1619), but, despite the signature, it may well be a later copy of Manṣūr's original.

71 THIS PAGE Storm on the Sea of Galilee, with the Gadarene swine. Album leaf. c.1650. 45.6 × 31.5 cm (page); 16 × 11.2 cm (within margins). European engraving, tinted, inlaid and mounted, with gouache enlargements.

still a good one, though in our highly eclectic modern culture Ruskin seems a figure from a vanished age. Prejudice, however, often turns out to be stubbornly entrenched, and the European viewer would do well to suppress any tendency to believe that Mughal painting might have been better had it been stylistically more homogeneous.

Admittedly some Mughal versions of imported European prints are apparently so slavishly true to the original that we might almost conclude that the painters' aim was a facsimile copy. To be fair to them, however, they were entirely under their employers' orders; and to be fair to Akbar and Jahāngīr, their European contemporaries, notably the Habsburg emperor Rudolf II, with whom, had they known, they had so much in common, were some of the most eclectic collectors of all time. The Mughal painters' recourse to modelling, stereoscopic perspective and the use of *sfumato* and

L'ennemy enuieux du bon heur et victoire
De ce Prince, ou la France auoit tout son espoir

72 PAGE 104 Safavid prince with a falcon on his wrist, perhaps Shāh 'Abbās II. Album leaf. Period of Shāh Jahān (1627–57) with rich late seventeenth or eighteenth century marginal illumination. From the Polier album. 17 × 9.6 cm. Gouache and gold inks on paper.

73 PAGE 105 The Dauphin, François of Valois, son of Francis I of France. Later sixteenth century French engraving, tinted and inlaid into a surround of cherubs holding a crown and the lion lying down with the lamb, themes which frequently occur in portraits of himself ordered by Jahāngīr. c.1610–20. 20.4 × 28.7 cm. Ink and wash on paper.

74 THIS PAGE Storm on the Sea of Galilee. Album leaf. c.1650. 11.3 × 8.8 cm. Gouache and gold inks on paper. The lavish later seventeenth or eighteenth century marginal illumination is typical of the Polier album from which the present sheet comes.

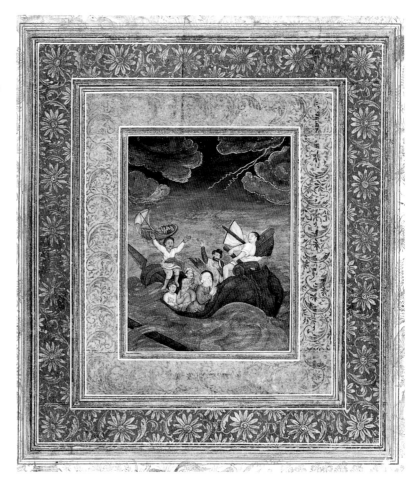

other European techniques to convey distance by colour gradations is, however, even more marked in the treatment of themes of non-European origin, including natural history painting for Jahāngīr; and many apparently facsimile copies of European subjects turn out on closer inspection to be ingenious pastiches of more than one source, sometimes slyly transmuted. There is, therefore, little evidence for the conclusion that eclecticism in Mughal art – whether of style or source material, either because the painters had no option but to take the second-rate models which happened to come their way or because they were unable to combine incompatible elements into an artistically productive style – brought a decline in quality. On the contrary it was precisely the fusion of styles – Indian, Persian and European – which gave Mughal painting its individuality and force.

— 7 —

PAINTING UNDER SHĀH JAHĀN AND AWRANGZĪB

By the accession of Shāh Jahān in 1628 the pace of Mughal expansion had slackened. The maintenance of order in the Mughals' already vast dominions was increasingly difficult and their campaigns against their neighbouring rivals and enemies steadily more inconclusive and more expensive in men and munitions. A military expedition to Central Asia in 1647, prompted perhaps as much by nostalgia for Shāh Jahān's Mughal ancestors' home as by fear of Safavid incursions from Persia, with the aim of establishing an Uzbek-Mughal axis linking Bukhara with Delhi, was, moreover, an ignominious failure.

A prudent ruler's response to increasing financial stringency could well have been to allow the Imperial studio to run down, and, although penny-pinching was scarcely consistent with the Mughal style of life, this is partly what occurred. Shāh Jahān's only major manuscript commission was a chronicle glorifying his reign, the *Pādshāhnāme*, the presentation copy of which, now in the Royal Library at Windsor, is dated 1067/1656–7. It is magnificently, though very unevenly, illustrated, most of the paintings being concentrated on the first decade of his reign. This could have been because the writing of the chronicle covered twenty years or so and the illustrations were executed simultaneously with the text, and over this long period Shāh Jahān's taste felt the pressure of his straitened finances.

It would, however, be quite wrong to suggest that Shāh Jahān's patronage shows any real cut-back. He and his family were extravagant builders all over the Mughal domains and erected not only the Taj Mahal (c.1632–47) but also new palaces inside the forts at Lahore and Agra, the Great Mosque at Agra and a whole new palace-city at Delhi which was to be his capital, Shahjahanabad, founded in Muḥarram 1048/May 1639, with one of the largest mosques in the whole of Islam and his palace, the Red Fort, there.

Shāh Jahān's unsuccessful attempts to emulate the imperial ambitions of the first Mughal emperors, and his lavish patronage of architecture, like the encomiastic *Pādshāhnāme*, suggest that the arts were justified in his eyes by the lustre they shed on him as a ruler. In the Imperial albums compiled for Jahāngīr in the latter part of his reign the marked stylistic unity achieved by the different painters working for him makes it rather more useful to group their work by subject matter, as has been attempted with the illustrations here, rather than by their individual production. To a considerable extent Shāh Jahān's studio was the heir to that style, for the changes in its personnel in the 1630s were in any case gradual. Like the white marble, often with *pietra dura* inlay, he favoured for his grandest buildings such as the Taj Mahal at Agra, it produced an effect which was cool, brilliant and smooth.

Though albums made for Shāh Jahān are famous for their floral margins (in fact, quirkily fantastic as well as botanically accurate), their subject matter is narrower in range. Most favoured were stiffly formal single portraits. Sometimes, even, new heads were added to stereotyped bodies. This may give some of the portraits a misleading family likeness: for example, that identified as the ambassador of the Safavid Shāh Ṣafī, Muḥammad ʿAlī Beg, painted by Hāshim c.1631 (Victoria and Albert Museum, IM 25–1925), is similar to another portrait of a Safavid official in the British Museum who may not be the same person at all. However, as is clearly apparent from drawings of State occasions like Shāh Jahān's accession durbar of 1628 his painters also readily seized any opportunity to depict figures in large groups. The identifications added to the figures in the preliminary sketches were not merely for the sake of the painters, since worked-up pages of court scenes in the *Pādshāhnāme* also bear them. In many of the pages executed for Jahāngīr, or copies of them, which were mounted for Shāh Jahān (in, for example, the Kevorkian album in New York) the additions and touching-up they underwent deprive them of spontaneity, and the manneristic polish they acquired suggests that the naturalism Jahāngīr so prized had gradually become a secondary consideration.

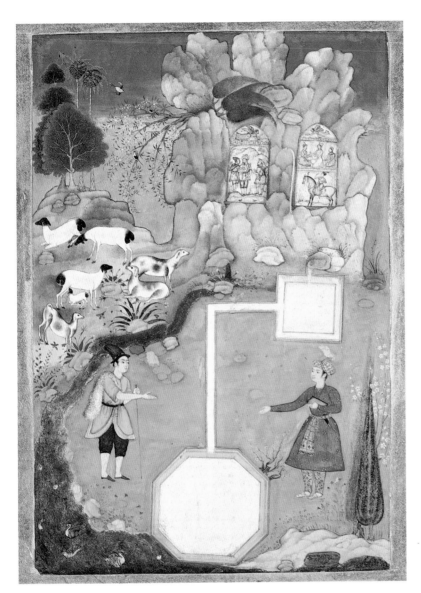

75 The legendary sculptor Farhād beside the pool at the entrance to the tunnel he dug through Mount Bisutun. Album leaf, based on an illustration to *Khusraw ū Shīrīn*, one of the five books of Niẓāmī's *Khamsa*. c.1605. 16.2 × 10.8 cm. Gouache on paper.

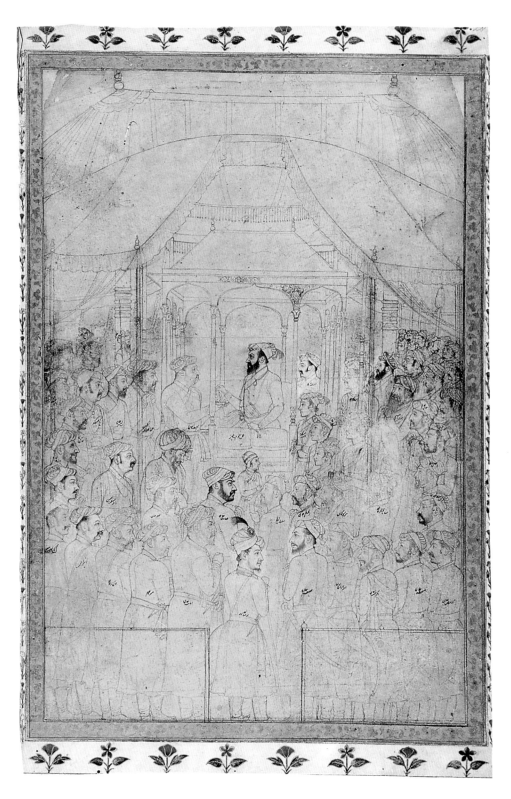

76 PAGE 110 Preliminary drawing for the accession durbar of Shāh Jahān in February 1628, as illustrated in the *Pādshāhnāme*, the principal chronicle of his reign. Signed by Anūp Chatōr. Datable 1628. 30.2 × 20.1 cm. Ink on paper with corrections in white. The mounts are eighteenth century. Shāh Jahān is shown with generals, rajahs and princes, receiving a necklace from his vizier, Abu'l-Ḥasan Āṣaf Khan. The corrections are all to the heads: costumes, particularly behind the balcony in the foreground, are perfunctorily rendered. The identifications of the figures were a guide to the colourist, who would have transcribed them in gold for the information of the reader.

77 PAGE 111 Standing courtier, Bahmānyār, son of Āṣaf Khan and brother of Nawāb Shāyaste Khan Iʿtiqād Khan (d. 1671). Signed by Muḥammad Nādir al-Samarqandī. Period of Shāh Jahān (1627–57). 21.1 × 12.7 cm. Gouache on paper.

78 Jahāngīr with a prince holding falcons. Composite portrait of c.1640, when the later portrait of the prince was added. 20 × 15.5 cm (inside margins). Gouache on paper.

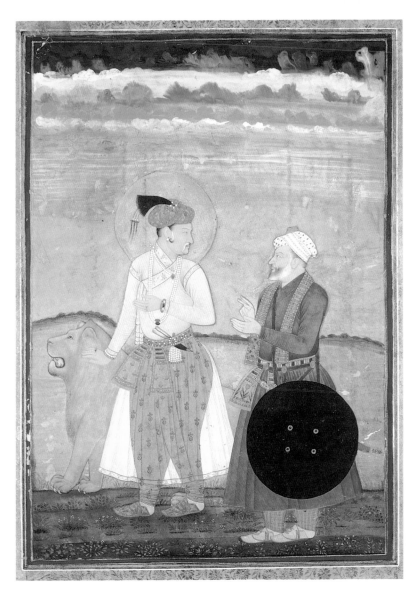

79 Jahāngīr and a lion with his vizier and brother-in-law, Abu'l-Ḥasan Āṣaf Khan, Iʿtimād al-Dawla. c.1640. From the Polier album. 26.4 × 18.4 cm. Gouache on paper.

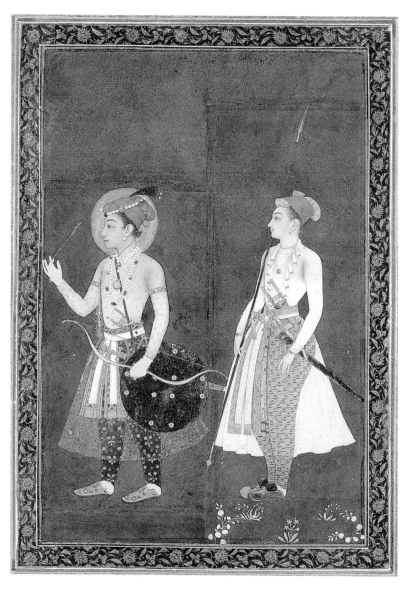

80 The princes
Awrangzīb (b. 1618)
right and Murād
Bakhsh (b. 1624) left.
Composite portrait,
c.1635. 20.3 × 13.5 cm.
Gouache on paper.

81 OPPOSITE Krishna
and the Pandavas
watering their horses,
from the copy of the
Razmnāme (a
translation of the
Hindu epic, the

Mahābhārata) made for
ʿAbd al-Raḥīm, Khān-i
Khānān in 1025/1616–7.
Attributed to Kamāl.
35.9 × 26 cm. Gouache
on paper.

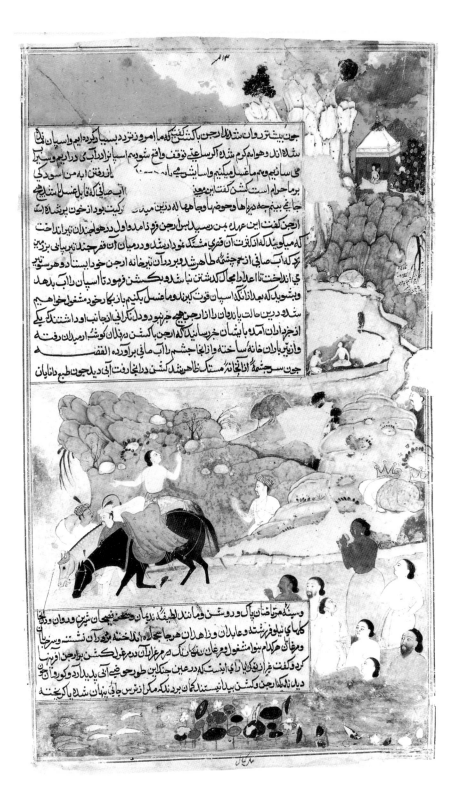

82 OPPOSITE
Muḥammad-qulī Quṭb
Shāh of Golconda
enthroned and
watching dancers.
Golconda, c.1586–90.
17 × 8.4 cm. Gouache
on paper. One of a
series of miniatures
incorporated
subsequently into a
manuscript of the
Divan of Ḥāfiẓ dated
1053/1643–4.

What is strikingly missing, moreover, is the syncretism of the European, Muslim and Hindu elements, religious, cultural and stylistic, of painting under Akbar and Jahāngīr. This may reflect Shāh Jahān's greater commitment to Muslim orthodoxy and the decline from favour of the Hindu element in the Mughal state. Possibly for the same reasons he also evidently handed over some of the painters of his studio to his much-indulged favourite son, Dārā Shikōh, who was killed in 1658. Yet the brilliance and gloss, the elimination of jarring features, were also deliberately cultivated and have often been said to represent in a certain sense a culmination of the Mughal style. This judgement may strike the reader as strange, for it is close to the suggestion that a painter like Bronzino was the culmination of the Italian Renaissance. It is, moreover, noticeable that for recent critics the eclecticism of earlier Mughal painting has been easier to swallow than the mannerism of Shāh Jahān's favoured style, which seems then to have been achieved at too heavy a cost. As Milo Cleveland Beach has remarked a propos of the virtual elimination of the Hindu elements under Akbar and Jahāngīr, 'the history of later Imperial Mughal painting is a story of heavy blossoms supported by shallow roots'. It left little or no room for further development, and the paintings commissioned for Awrangzīb are scarcely more than an ossification of the Imperial style.

Innovation in painting after Shāh Jahān shows itself very much in provincial Mughal work, often smaller and simplified versions of Imperial models and for social, ethnic and religious groups which remained in closer contact with their Hindu environment. Even under Akbar fine painting was by no means a monopoly of his studio. Side by side with rather less lavish copies of grand manuscripts made at Akbar's orders for distribution to his officials there were works commissioned by officials, like ʿAbd al-Raḥīm, Khān-i Khānān, who maintained their own studios. One of his early commissions was a *Ramāyana* (1589–98), now in the Freer Gallery in Washington, in which artists like Mushfiq and Qāsim, who were still working for him almost two decades later (on a *Shāhnāme* and an anthology of romances by Amir Khusraw Dihlavī), participated.

Interestingly, neither Mushfiq nor Qāsim appears to have worked for Akbar or for Jahāngīr. There was also a considerable turnover in the painters the Mughal emperors employed. Jahāngīr's overwhelming patronage of album pages, which were essentially to please the eye, rather than illustrated texts makes it ironic that it was not he but Akbar who was reputedly illiterate; but he may well have considered that the Imperial library had been so enriched with

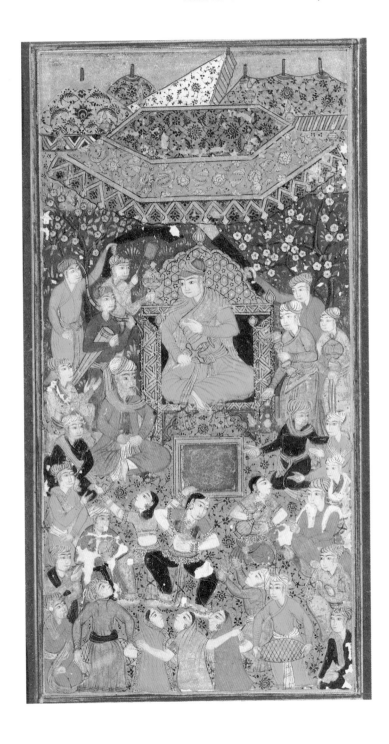

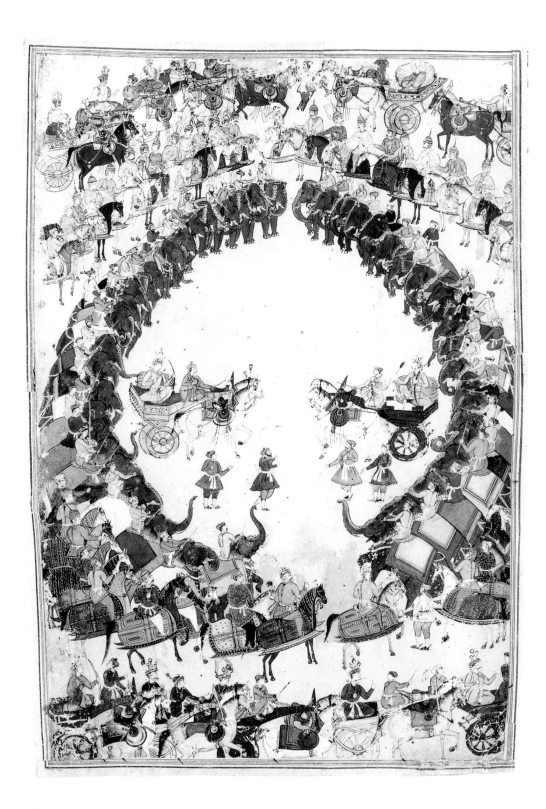

manuscripts of the Mughal classics that no further copies of them were necessary. The change in emphasis on Jahāngīr's accession in 1605 from calligraphed texts to calligraphic specimens and from sequences of illustrations, often very numerous, to discrete pages must have led him to prune the staff of Akbar's studio. Many of the painters he dismissed gravitated to provincial centres or to the libraries of his officials, some of whom, like ʿAbd al-Raḥīm, were not only patrons of painting but active scholars too. ʿAbd al-Raḥīm's studio very probably accompanied him when, at various stages in his career, he was posted to the provinces, to Gujarat or the Deccan, but since he was more interested in scholarship than in illustration as such, many manuscripts ordered for him tell us little of their work. The Imperial studio was, however, so closely associated with the court that any change of ruler must have drastically changed its staff. Under Shāh Jahān, for example, one of Jahāngīr's most admired painters, Manōhar, went to his son, Dārā Shikōh; while the almost equally admired Bishn Dās went to Ẓafar Khān.

There are also important paintings by artists who left the Imperial studio to work for commercial patrons, including the Hindu courts. These often show the persistence of local styles away from the Mughal court – Persian influence (most viable at Golconda in the Deccan) or the North Indian Sultanate style – and of local subject matter, including Sanskrit or Hindu epic and romance and Rāgamālās, albums showing the modes of Indian music in pictorial form, grouped into 'families'. (For all the Mughals' appreciation of music, Rāgamālās do not appear to have appealed much to them.) The *Manley Rāgamālā* of *c*.1610, for instance, like early seventeenth-century painting in Rajasthan at Bundi and then Mewar, particularly under Jagat Singh of Udaipur (1628–52), clearly shows Mughal influence, though the overall effect is strikingly reminiscent of painting in the *Ṭūṭīnāme* completed for Akbar in the 1560s.

After Awrangzīb's death this grandest of Imperial libraries was gradually dispersed by his feckless successors. Many of its finest paintings went off to Persia as booty with the Afghan conqueror Nādir Shāh, who sacked Delhi in 1739, and are still there. Many others were, however, collected by officials of the East India Company (both Warren Hastings and Clive were noted collectors) and now ornament London collections, both public and private – including the British Museum, the British Library, the Victoria and Albert Museum, the India Office, the Royal Asiatic Society, and the Royal Library at Windsor. This makes London a particularly good place to study Mughal painting. But it would be unfair to compare

83 OPPOSITE Battle-scene from the copy of the *Razmnāme* made for ʿAbd al-Raḥīm, Khān-i Khānān. 34 × 22.6 cm (inside margins). Gouache on paper.

84 OPPOSITE Gauri Rāginī. Night-scene in a richly painted garden with a woman bearing crossed flowering branches. From the *Manley Rāgamālā*, c.1610. 20.5 × 14.7 cm (inside margins). Gouache on paper.

85 THIS PAGE Muḥammad Quṭb Shāh or his son ʿAbdallāh receiving an embassy. Golconda, 1611 or 1626. Gouache on paper.

the acquisitions of British collectors in India to the depredations of Nādir Shāh. The Mughal studios between 1560 and 1700 produced so much and on such a magnificent scale that most of the national and city museums of Europe and the United States have important collections of their own, some of them going back to the early seventeenth century. The museums, libraries and private collections of the Indian sub-continent are at least as important, and as their contents become better known they may well revolutionise what we know at present of Mughal art.

ILLUSTRATION ACKNOWLEDGEMENTS

Abbreviations
BM = British Museum
BL = British Library
V&A = Victoria and Albert Museum

Frontispiece BM 1980. 5–12. 09

1, 13 BM 1913. 2–8. 1. Presented by the NACF, with a contribution from Graham Robertson Esq.

2 BM 1948. 10–9. 071

3 BM 1961. 12–15. 01. Brooke Sewell Fund

4 BM 1942. 1–24. 02. Presented by the NACF

5 BM 1925. 9–29. 02. Presented by the Revd. Straton Campbell

6 BM 1969. 3–17. 04. Presented by Mr and Mrs Anthony N. Sturt

7 BM 1974. 6–17. 021 (28)

8 BM 1920. 9–17. 02

9 BM 1974. 6–17. 017 (33)

10 BM 1983. 7–27. 01

11 Washington DC, Freer Gallery of Art 63.4 verso

12 BM 1930. 11–12. 01

13 See fig. 1

14 BM 1920. 9–17. 033

15 BM 1925. 9–29. 01. Presented by the Revd. Straton Campbell

16 BM 1946. 10–10. 02. Marjorie Coldwell Fund

17 BM 1954. 5–8. 01

18 Washington DC, Freer Gallery of Art 48.8

19 BM 1920. 9–17. 05

20 BM 1921. 4–11. 04

21 University of London, School of Oriental and African Studies, MS 10102. Gift of Miss Ousely

22 BL Or. 1362 f. 135b

23 BM 1949. 2–12. 04 (1)

24 BM 1965. 7–24. 05

25 BL Or. 12208 f. 195a. Bequest of W. Dyson Perrins

26 BL Or. 3714 f. 478a

27 BM 1934. 1–13. 01 (a)

28 BM 1974. 6–17. 03 (26)

29 V&A IS 2-1895 21-22/117 (verso)

30 BL Or. 12208 f. 325b

31 BM 1921. 10–11. 03
32 BM 1974. 6–17. 010 (3)
33 BM 1920. 9–17. 013 (13)
34 BM 1920. 9–17. 0290
35 BM 1942. 1–24. 06. Presented by the NACF
36 BM 1920. 9–17. 0281 (1)
37 BM 1949. 12–10. 010
38 BM 1989. 8–18. 1
39 BL Or. 5302 f. 30a
40 BM 1948. 10–9. 068. Bequest of P. C. Manouk Esq. and Miss G. M. Coles, through the NACF
41 BM 1955. 10–8. 041. J. C. French collection, purchased with the aid of the NACF
42 V&A IM 135-1921
43 BM 1936. 6–13. 01
44 BM 1983. 10–15. 1
45 Private collection
46 BM 1933. 6–10. 01. Presented by the NACF
47 BM 1921. 10–11. 01
48 BM 1920. 9–17. 0248
49 Oxford, Ashmolean Museum, Reitlinger Bequest, 1978.2597
50 BL Or. 4615 f. 34b
51 BM 1920. 9–17. 013 (34)
52 BM 1948. 10–9. 072. Bequest of P. C. Manouk Esq and Miss G. M. Coles, through the NACF
53 BM 1942. 1–24. 03
54 BM 1937. 7–10. 0331. Bequest of Charles Ricketts and Shannon ARA
55 BM 1937. 7–10. 0332
56 BM 1920. 9–17. 0216
57 BM 1982. 5–29. 01
58 (and cover) BM 1948. 10–9. 069. Bequeathed by P. C. Manouk Esq. and Miss G. M. Coles through the NACF
59 BM 1920. 9–17. 015
60 BM 1920. 9–17. 013 (2)
61 V&A IM 23-1925
62 BM 1969. 3–17. 03. Presented by Mr and Mrs Anthony N. Sturt
63 BM 1969. 3–17. 06. Gift of Mr and Mrs Anthony N. Sturt
64 BM 1939. 5–13. 013
65 BM 1953. 2–104. 02. Bequeathed by Sir Edward Marsh KCVO, CB, CMG through the NACF
66 BM 1920. 9–17. 0329
67 BM 1920. 9–17. 03
68 BM 1948. 10–9. 084. Bequest of P. C. Manouk Esq. and Miss G. M. Coles, through the NACF
69 BM 1969. 3–17. 01. Presented by Mr and Mrs Anthony N. Sturt
70 BM 1969. 3–17. 02. Presented by Mr and Mrs Anthony M. Sturt
71 BM 1920. 9–17. 031
72 BM 1920. 9–17. 044
73 BM 1954. 5–8. 02
74 BM 1920. 9–17. 032
75 BM 1920. 9–17. 0267
76 BM 1920. 9–17. 013 (27)
77 BM 1920. 9–17. 013 (12)
78 BM 1920. 9–17. 0286
79 BM 1920. 9–17. 046
80 BM 1920. 9–17. 0287
81 BM 1958. 7–12. 019
82 BM 1974. 6–17. 06 (1)
83 BM 1981. 7–3. 01
84 BM 1973. 9–17. 02
85 BM 1937. 4–10. 01

FURTHER READING

Much the most interesting documentation of Mughal art and culture is in the contemporary sources, Muslim as well as European. A selection, all in English, follows. Out-of-print works or works originally published in India are often available in modern Indian reprints.

The Ā'in-i Akbarī of Abu'l-Faḍl ʿAllāmī, I-II, translated by H. Blochmann and H.S. Jarrett (Calcutta, 1927–49)

Akbar and the Jesuits, by P. du Jarric, translated by C.H. Payne (London, 1926)

The Bābur-Nāma in English, translated by A.S. Beveridge (London, 1922; 1969)

The narratives of William Hawkins (1608–13) and William Finch (1608–11) in *Early travels in India 1583–1619*, edited William Foster CIE (Oxford-London, 1921)

Jahangir and the Jesuits ... from the Relations of F. Guerreiro (letters of 1607–1608), translated by C.H. Payne, (London, 1930)

Letters from the Mughal court. The first Jesuit mission to Akbar (1580–1583), J. Correia-Alfonso SJ, editor (Bombay, 1980)

Niccolao Manucci, Storia do Mogor, or Mogul India, I-IV, translated by William Irvine (London, 1907–8; Calcutta, 1966)

The embassy of Sir Thomas Roe to the court of the Great Mogul 1615–1619, As narrated in his journal and correspondence, edited by William Foster (Hakluyt Society, London, 1899)

Tūzuk-i Jahāngīrī (Memoirs of Jahangir), I-II, translated by A. Rogers and H. Beveridge (London, 1909–14)

Select bibliography of secondary sources

Douglas Barrett and Basil Gray, *Painting of India* (Skira, Geneva, 1963)

Milo Cleveland Beach *et al., The Grand Mogul. Imperial painting in India 1600–1660* (Williamstown, Massachusetts, 1978)

Milo Cleveland Beach, *Mughal and Rajput Painting. The New Cambridge History of India* I:3 (Cambridge, 1992)

Milo Cleveland Beach, *The Imperial image. Paintings for the Mughal court* (Freer Gallery of Art, Smithsonian Institution, Washington DC, 1981)

Michael Brand and Glenn D. Lowry, *Akbar's India: Art from the Mughal City of Victory* (Asia Society, New York, 1985)

Percy Brown, *Indian painting under the Mughals* (Oxford, 1924)

Asok Kumar Das, *Splendour of Mughal Painting* (Marg, Bombay, 1986)

Richard Ettinghausen, *Paintings of the Sultans and Emperors of India in American collections* (New Delhi, 1961)

Bamber Gascoigne, *The Great Moguls* (London, 1971)

Basil Gray, editor, *The Arts of India* (Phaidon, Oxford, 1981)

Dalù Jones, editor, *A Mirror for Princes. The Mughals and the Medici* (Marg, Bombay, 1987)

Jeremiah P. Losty, *The art of the book in India* (British Library, 1982)

F.R. Martin, *The miniature-painting and painters of Persia, India and Turkey*, I-II (London 1912; 1971)

Amina Okada, *Imperial Mughal Painters. Indian Miniatures* translated by Deke Dusinberre (Flammarion, Paris, 1992)

Pratapaditya Pal, editor, *Master artists of the Imperial Mughal court* (Marg, Bombay, 1991)

R.H. Pinder-Wilson, *Paintings from the Muslim courts of India*, exhibition catalogue (British Museum, 1976)

Robert Skelton *et al., The Indian heritage. Court life and arts under Mughal rule*, exhibition catalogue (Victoria and Albert Museum, 1982)

Norah M. Titley, *Persian miniature painting and its influence on the art of Turkey and India. The British Library collection* (British Library, 1983)

Stuart Cary Welch, *Imperial Mughal painting* (New York, 1977)

Stuart Cary Welch, *India. Art and culture 1300–1900* (Metropolitan Museum, New York, 1985)

Stuart Cary Welch *et al., The Emperor's Album. Images of Mughal India* (Metropolitan Museum of Art, 1987)

INDEX

Figures in **bold** refer to illustrations